IMAGES of America
INDIAN ROCKS BEACH

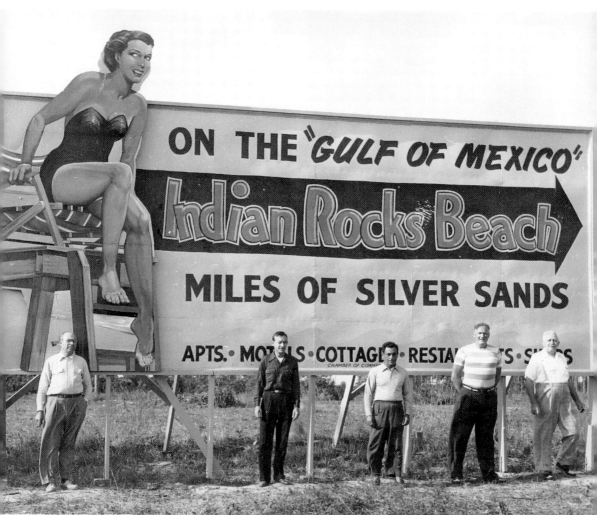

Indian Rocks Beach has long been promoted as a tourist destination. In the 1920s boom period, girls dressed as nymphs dancing on the beach (see cover) were filmed "to acquaint people in the north with the charm of Florida's winter season." With the coming of the automobile age following World War II, this giant billboard was used to lure motorists over the bridge to enjoy "miles of silver sands."

ON THE COVER: The December 5, 1925, *Indian Rocks Sentry* describes this scene with the headline, "Indian Rocks Beach is choice of dancing stars for movie." The film was being made by the Inter-City Realty Company for promotional purposes.

IMAGES
of America

INDIAN ROCKS BEACH

Wayne Ayers, Nancy Ayers,
Jan Ockunzzi, and the
Indian Rocks Historical Society

ARCADIA
PUBLISHING

Copyright © 2010 by Wayne Ayers, Nancy Ayers, Jan Ockunzzi, and the
 Indian Rocks Historical Society
ISBN 978-0-7385-8600-7

Published by Arcadia Publishing
Charleston, South Carolina

Printed in the United States of America

Library of Congress Control Number: 2009943450

For all general information contact Arcadia Publishing at:
Telephone 843-853-2070
Fax 843-853-0044
E-mail sales@arcadiapublishing.com
For customer service and orders:
Toll-Free 1-888-313-2665

Visit us on the Internet at www.arcadiapublishing.com

*To Bill Brandon, for graciously providing us a treasure trove
of fascinating facts and stories in response to our queries*

Contents

Acknowledgments		6
Introduction		7
1.	Early Days	9
2.	Fishing	29
3.	Gulf Boulevard	41
4.	The Cottages	55
5.	Tourism	73
6.	Beach Life	89
7.	Community	103
8.	Hurricanes	121
About Indian Rocks Historical Museum		127

ACKNOWLEDGMENTS

The Indian Rocks Historical Society is fortunate to have an outstanding collection of photographs that have been donated over the years. This book would not have been possible without the participation of countless society members and friends, past and present, who have shared their photographs and their remembrances with the society.

In particular, we recognize the longtime contributions of Shera Haight Bie, a dedicated and enthusiastic member of the historical society who has made a deliberate effort to collect and organize pictures from our past. In addition to the historical photographs she has obtained from other early residents of our community, she and her husband Billy's family have contributed a large collection of images.

We also want to give special recognition to Bill Brandon, who has generously shared with us his sizable collection of beautiful old postcards and photographs. More than that, he has enriched our knowledge immeasurably of this community's history. His love for the people and places of Indian Rocks Beach are apparent in his eagerly given, vivid recollections.

Others who are part of our history and have made significant contributions of photographs and historical information are (in alphabetical order) Berniece Gerber, Bette Zubrod Holloway, Martha Moseley Johnson, R. B. Johnson, and Joseph Knight Jr.

Other people and organizations whose valuable contributions to this book are appreciated include Heritage Village Archives and Library archivist Alison Giesen, Largo Library and the Largo Historical Society, Largo Historical Society members Bob Delack and Charlie Harper, Florida State Archives, Nancy Meares Miller, Barry Broeske, Charles Foertmeyer, Norma Boza-Keesler, and Jill Klein.

Unless otherwise noted, all images appear courtesy of the Indian Rocks Historical Society.

The following references were especially helpful in preparing the text:
Hurley, Frank T., Jr. *Surf, Sand, and Post Card Sunsets: A History of Pass-a-Grille and the Gulf Beaches.* 1977.
Indian Rocks Historical Society. *Indian Rocks As It Was: A Pictorial History.* Indian Rocks Beach, FL: IRB Publishing, 2006.
Indian Rocks Beach Area Historical Society. *Indian Rocks: A Pictorial History.* St. Petersburg, FL: Great Outdoors Publishing Company, 1980. (Out of print.)
Indian Rocks Sentry
St. Petersburg Times

INTRODUCTION

Pioneer settler Harvey K. Hendrick, who arrived in Indian Rocks Beach around 1890, would remark years later, "I liked the place, I thought it was the most beautiful place on God's green footstool, and I think so yet."

Throughout its history, Indian Rocks has been considered a special place by those fortunate to discover it.

Native American tribes visited in the 1500s, and found healing springs along with an abundance of sustaining fish and wildlife. Pioneer families came to settle the Indian Rocks area on the mainland beginning in the mid-1800s. They were attracted by an abundant supply of fresh water that the natural springs provided, a soil and climate suitable to agriculture, and the bountiful fishing opportunities offered by the Gulf of Mexico and bay waters. They built a community by the late 1800s that turned Indian Rocks into one of the area's three main settlements, along with Pass-a-Grille and Clearwater Beach.

In 1883, four men sailed southward from Cedar Key, exploring the Gulf coast of Florida in search of the ideal spot to settle. Arriving in the Narrows where the old bridge was eventually built, they proclaimed, "This is it." Of the party, J. H. Hendrick and L. W. Hamlin would homestead their chosen place, now known as Indian Rocks Beach.

The barrier island became "Tampa's playground" in the early 1900s, when the Tampa and Gulf Coast Railroad built a spur from the big city to the beach. Tampans flocked to their newly discovered paradise, seeking relief from the summer heat and the pressures of boom-era city life. The shoreline retreats they built, ranging from cottages to grand beach homes, offered a slice of heaven to the vacationers.

"One must see it, to know what beauty there is in sky and sea," H. H. Hamlin rhapsodized of an Indian Rocks Beach sunset in 1925. "Drink deep, ye lovers of Nature, for tomorrow you may drink again, but never drink your fill!"

Following World War II, a new generation of ex-GIs and their baby-boom families discovered the wonders of Indian Rocks Beach. The 1950s and 1960s saw creation of the longest fishing pier in Florida and the biggest attraction of all—Tiki Gardens. The multi-acre Polynesian paradise drew 300,000 visitors a year during its prime years.

The dream of owning a waterfront home became possible when dredge and fill operations created fingers of suitable land from a mangrove swamp.

A cooperative community spirit gave Indian Rocks Beach an enduring cohesiveness that is so attractive to residents, even today. Churches, civic organizations, social groups, and government entities combined to sponsor events and offer activities and services that brought residents and visitors into community with the city and each other.

New winter residents, the snowbirds, arrived in the 1970s, filling the condominiums along the shore. Their presence bolstered the local economy and brought an influx of new ideas and tastes from around the country and the world.

A diverse, colorful blend of people from all age groups and places old and new, gives Indian Rocks Beach its unique, eclectic "cottage" character. It is a mix that residents prize and visitors seek out year after year.

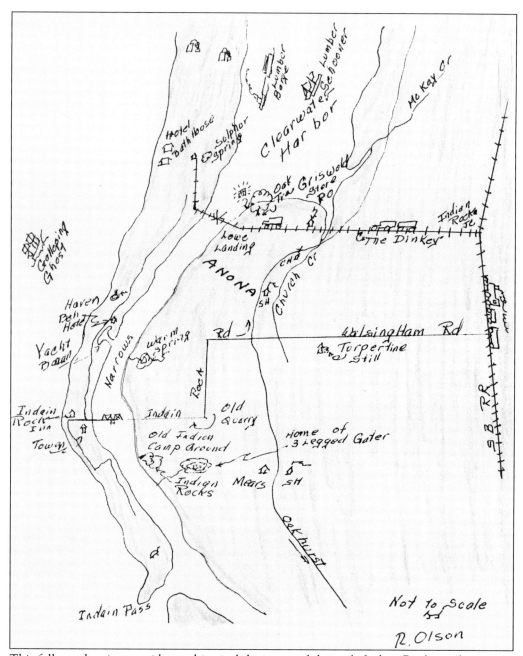

This folk art drawing provides a whimsical depiction of the early Indian Rocks settlement on the island and the mainland. The time period represented here appears to be in the 1920s, when both the auto and train bridges were bringing excursionists to the beach.

One

EARLY DAYS

Indian Rocks Beach got its start as a community on the mainland. A settlement called Indian Rocks was located in the vicinity of Anona, part of today's Largo. Citrus groves, farms, nurseries, and of course, fishing provided a livelihood for the early pioneers.

Attention moved to the barrier island following the building of railroad and auto bridges in the early 1900s. The beach was discovered by excursionists coming over mostly from Tampa in the beginning and later from more distant locales. An ever-increasing flow of visitors launched the area's first tourist boom. By 1920, a half dozen spacious wooden hotels provided rustic, yet comfortable accommodations.

Many of the visitors to the island became seasonal, even full-time, residents. Like the first settlers who were attracted by the beauty of the place, others have chosen to remain in this paradise by the sea.

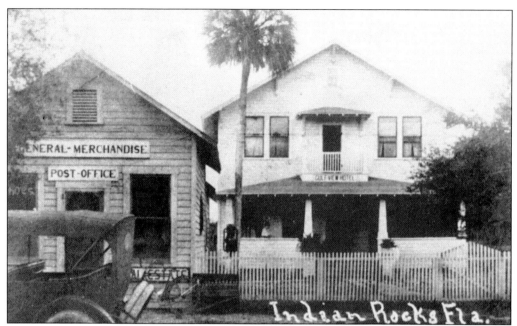

The original settlement of Indian Rocks was on the mainland side of the Narrows, a block east of the ferry crossing site where the auto bridge was built in 1916. Community activity centered on the combination post office and general store. Physician Dr. Max Friedlander served as postmaster and had his medical offices in the rear of the building. Next door was the Gulf View Hotel.

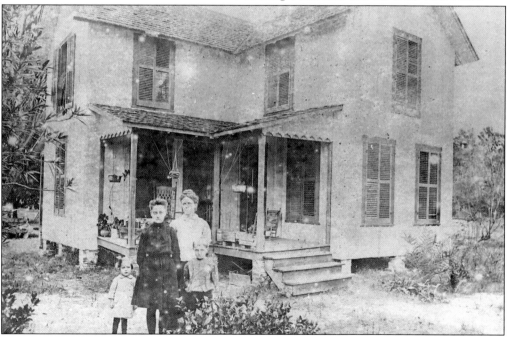

The first persons to homestead in the area were Capt. John T. Lowe and his wife, Laura Meares Lowe, who arrived from Cedar Key in 1859 with their extended families aboard his schooner *Seadrift*. The Lowe homestead was on the mainland in a settlement that became known as Anona. Their son Wesley's home, pictured here, is now preserved at Heritage Village in Largo.

The original settlement party included Captain Lowe's in-laws, the Meares. Pictured here is Lowe's mother-in-law, Miriam Roberts Meares (1804–1890), who was a dressmaker. The plaid dress is no doubt her handiwork. (Courtesy of Heritage Village Archives and Library.)

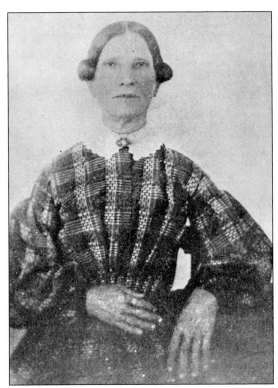

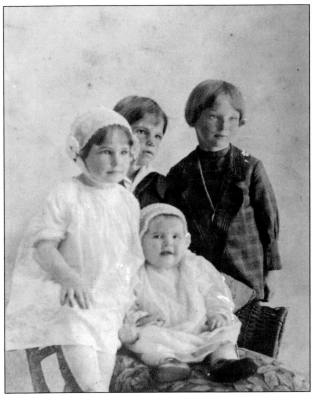

By the 1880s, the Lowes and Meares were joined by the Hammock, Wilcox, and Whitehurst families, all of whom would play significant roles in the Indian Rocks community's development for years to come. This 1918 family portrait shows the great-grandchildren of Miriam Roberts Meares. Pictured are Janice and Bert Meares (both at left) and their cousins Everett (baby) and Joyce Wilcox. (Courtesy of Heritage Village Archives and Library.)

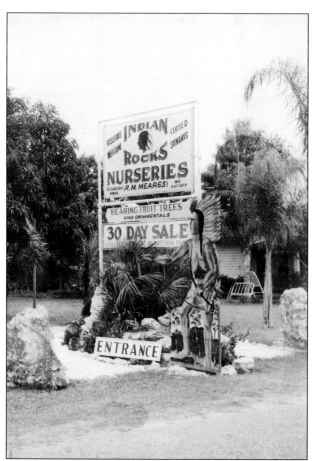

The Meares and Wilcox families would later become prominent in the nursery business. Richard Maurice Meares founded Indian Rocks Nurseries in 1912. It was one of the largest plant nurseries in the state during the 1940s. Wilcox Nurseries still operates from its original location on Indian Rocks Road. (Courtesy of Largo Library and Largo Historical Society.)

The Anona School class of 1896–1897, pictured here, included many sons and daughters of early Indian Rocks families. Most are Lowe, Meares, Hammock, or Hendrick family members.

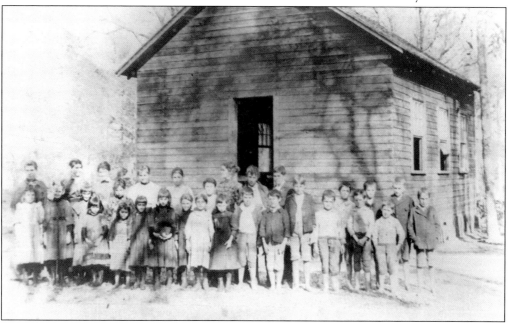

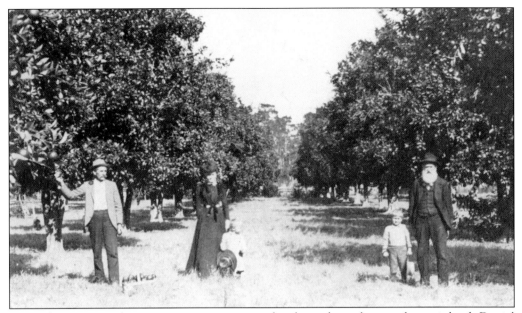

Citrus farming was the main occupation engaged in by early settlers on the mainland. Daniel McMullen (right) is shown in his orange grove around 1900, along with daughter Nannie and son-in-law James N. Hardage. The McMullens were a prominent family of the pioneer era, and many descendents still reside in the area. (Courtesy of Largo Library and Largo Historical Society.)

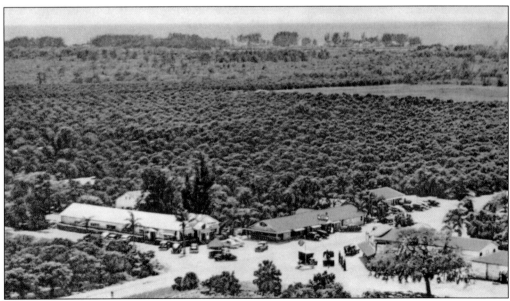

The citrus industry would continue to grow. By World War II, fruit trees covered much of the area, and citrus farming became Pinellas County's major industry. This view shows groves spreading out from Harry Ulmer's Indian Rocks Fruit Company in the mid-1940s. The packing plant stood where Walgreens is now located at the corner of Oakhurst and Walsingham Roads.

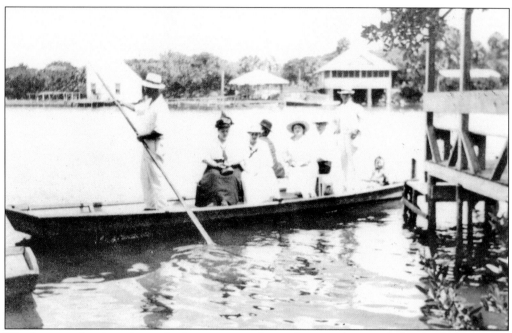

The barrier island in the early days was popular with picnickers and sightseers, known as excursionists. Landowners were Harvey K. Hendrick and L. W. Hamlin, who divided the island in the 1880s. Visitors arrived on Hendrick's 20-foot scow, shown here. A nickel per passenger toll was charged.

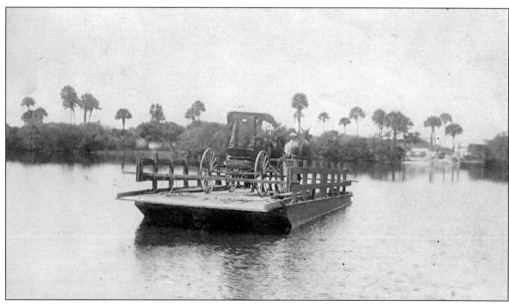

Hendrick also operated this raft, which was used for carrying vehicles and supplies from the mainland.

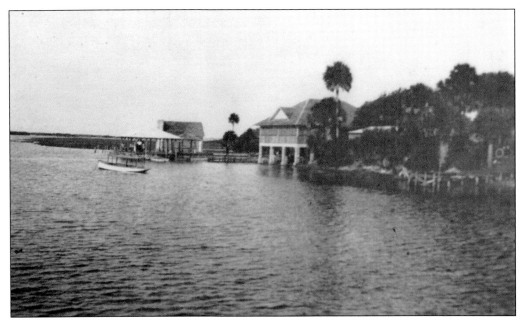

This photograph shows the ferry landing site on the mainland side in 1914. The large white building, which can also be seen on the opposite page, is the old general store. Camillus Brandon operated the business as a grocery store and post office for 20 years, taking advantage of its prime location beside the bridge that had been built in 1916. The building remained until the 1990s. (Courtesy Largo Library and Largo Historical Society.)

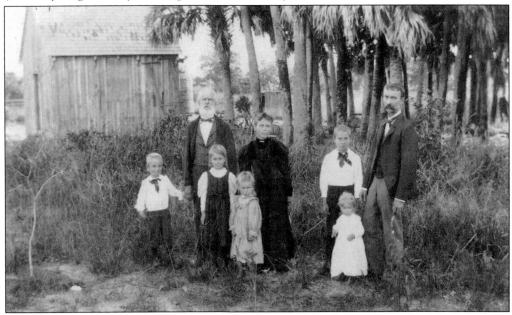

The Hendrick family was the first to settle on the barrier island. Here Harvey Hendrick (right) is shown with his wife, Rosa, and family in 1896. Some years later, Hendrick wrote of his wife and old homestead, saying he remembered the days "when my dear companion and I watched the beautiful sunsets . . . and listened to the murmuring of the restless ocean." (Courtesy of Heritage Village Archives and Library.)

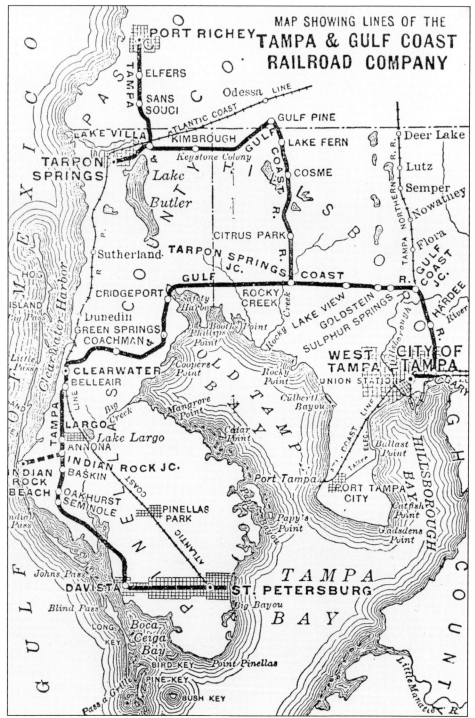

In 1914, the Tampa and Gulf Coast Railroad (T&G) ran a spur line across the bay to Indian Rocks Beach. The route became "the Tampa connection," by which the city dwellers discovered the beach. This map shows the T&G route, which also ran past Henry Plant's exclusive Belleview Biltmore Hotel at Belleair. Overflow guests of the hotel were accommodated at Indian Rocks Beach.

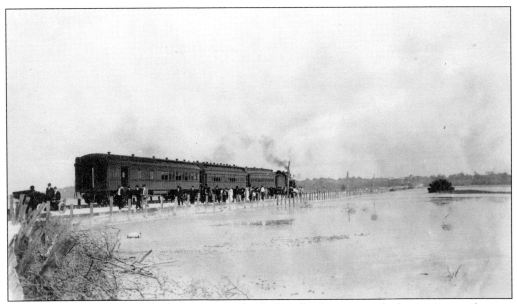

The T&G used one of its plusher trains on the Indian Rocks spur in the beginning, perhaps to build passenger traffic. It was later replaced with an open car that had bench seating. The less than first-class ride earned the rail line the derisive nickname "Tug and Grunt." (Courtesy of Heritage Village Archives and Library.)

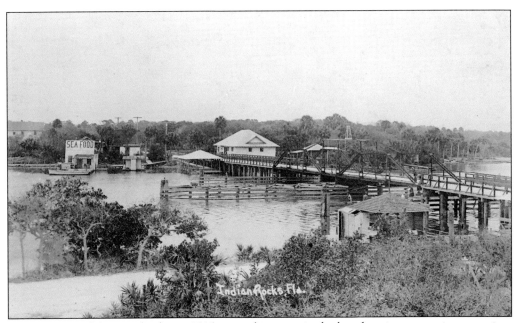

Construction of the auto bridge in 1916 spurred interest in the beach strip as a tourist attraction. Indian Rocks' community development shifted to the bridge vicinity and barrier island. This 1921 photograph shows the early grocery on the bridge and fish house on the mainland shore. The old ferry house, known as Hamlin's Landing, can be seen at lower right.

This view shows the bridge under construction in 1915. A plaque in the Narrows marks its location today.

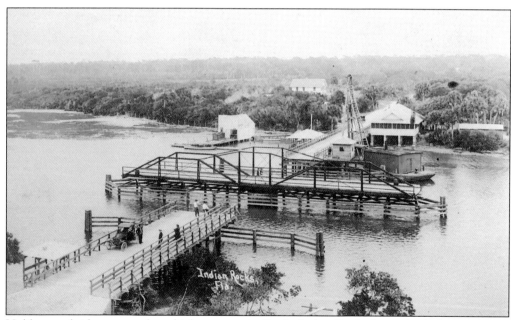

Unlike most bridges seen today, which open vertically, the Indian Rocks "swing bridge" rotated open to allow boat traffic to pass. This was accomplished by means of a giant key that the bridge tender turned with considerable effort to maneuver the span to its open and closed positions. This method was maintained throughout the 42-year existence of the bridge, which was never motorized.

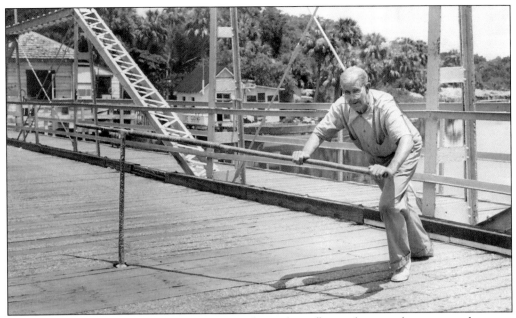

Longtime tender Kenneth "Cap" Ransom is shown here flexing his muscles to open the span. Ransom had the longest tenure of any bridge tender, taking over the position in 1938 and retiring in 1954 at the age of 76. He was also known for an adventurous journey he took at age 22 in his sailboat *Gazelle*, documented in the book *A Year in the Yawl*.

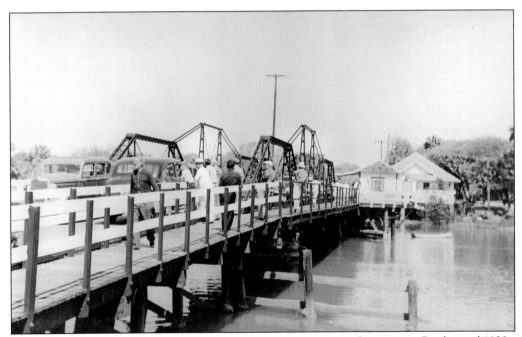

Bridge usage grew along with the beach's popularity as a tourist destination. By the mid-1930s, traffic jams on the span were common. Bridge tender Cap Ransom can be seen in the foreground overseeing the activity. (Courtesy of Heritage Village Archives and Library.)

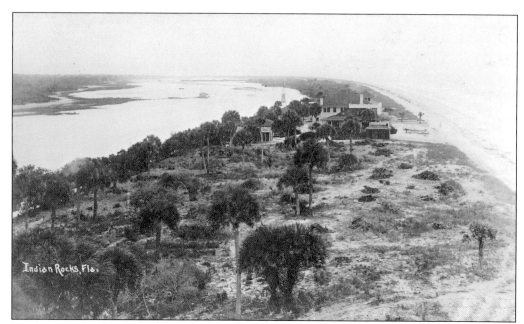

The barrier island was mostly a palmetto scrub wilderness when this photograph was taken from atop the water tower at the pavilion. John Hendrick's fish camp at "Johnny's Rocks" can be spotted in the distance on the waterway.

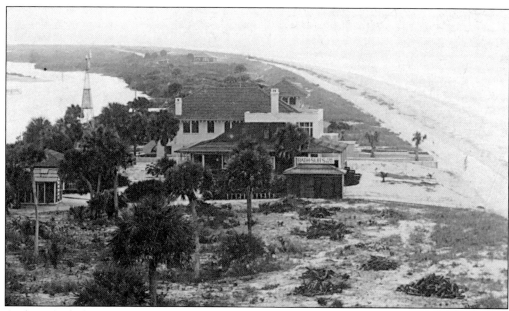

A closer look shows the Knox Hotel in the foreground, constructed around 1905. Next door is "The Castle," the impressive summer residence of Tampa cigar manufacturer Val Antuono, built in 1910. The home still stands at 30 Gulf Boulevard. Note the bathing suit rental station beside the hotel.

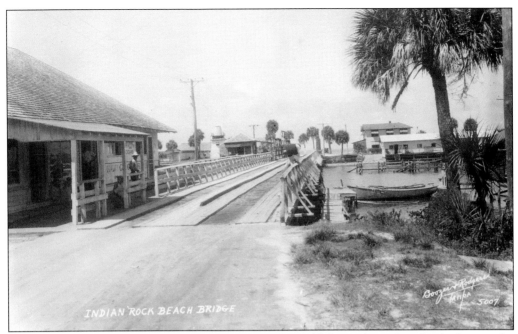

This 1925 view looking across the bridge toward the Gulf shows the Indian Rocks Inn on the right. Brandon's Pavilion can be seen behind the structures to the left. In the foreground is the combination post office/grocery store, which was a popular story-swapping place according to early accounts. That building remained until the 1990s, outlasting the bridge itself by 30 years.

Looking at the bridge from the opposite direction, the entryway to Indian Rocks Beach appears deserted on this sunny day in 1925. Perhaps the professional photographer preferred a shot without people or moving vehicles due to the long exposure times required by early cameras. This photograph was probably taken the same day as the one above.

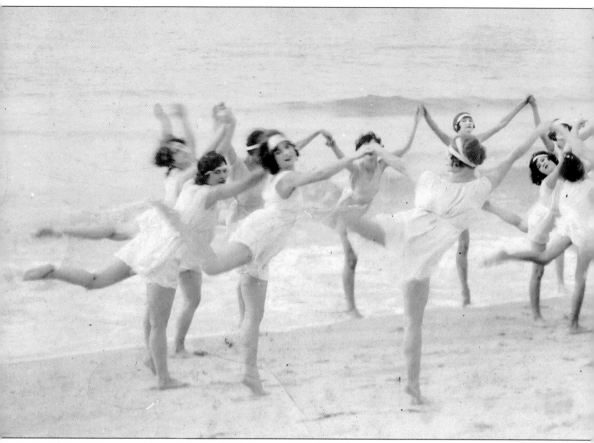

This scene enacted by members of "Mrs. Armour and her dancing class" was apparently part of the relentless promotion of the beach spurred by real estate developers and tourist bureaus during the 1920s boom era. The activity is described in the December 5, 1925, *Indian Rocks Sentry* newspaper article at right, which reports that motion pictures were taken of the girls dancing on the beach.

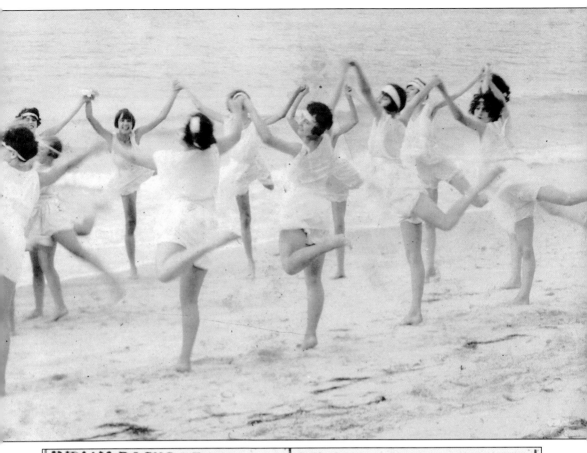

INDIAN ROCKS BEACH IS CHOICE OF DANCING STARS FOR MOVIE

A gay scene was enacted at Indian Rocks Beach Sunday afternoon when Mrs. Armour and 28 members of her dancing class posed and gamboled for motion pictures.

The large crowd at Indian Rocks Beach was surprised and highly entertained when many dancing girls exhibited their art before the camera of Dudley Reid. These charming young ladies dressed like nymphs performed admirably with a very fitting background and many visitors assembled to enjoy the artistic work of Mrs. Armour and her clever students.

No more ideal setting could be found for such a purpose and the beach and background of the beautiful Gulf of Mexico will make many a person yearn to journey there when the picture is exhibited in northern cities. Upon inquiry, it was stated the program filmed at Indian Rocks Beach Sunday was to be a part of a general plan to acquaint people in the north with the charm of Florida's winter season.

Miss Virginia McRay, who represented the City of Tampa at the Atlantic City Bathing Girl contest two seasons ago, was a member of the party and the charm of this petite little girlie was very much in evidence.

After several hours' work before the camera, the party was invited to lunch as the guests of the Inter-City Realty Company at their picnic.

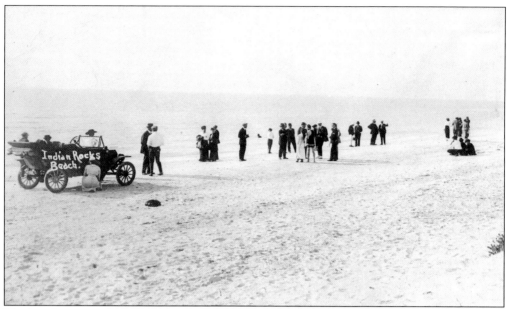

The beach was a scene of much activity in the days following completion of the auto bridge. This was likely an organized group of some sort, quite possibly real estate prospects, judging by some of the gesturing and intense discussion going on.

Brandon's Pavilion, built in 1915 on the beach near the bridge crossing, served for many years as the community's social center. In the early years, the pavilion offered rental bathing suits and "large sanitary rooms" where patrons could change from street clothes into their bathing attire.

The pavilion was a popular spot to hold family reunions. This is a gathering of the pioneer Hammock family in the late 1920s.

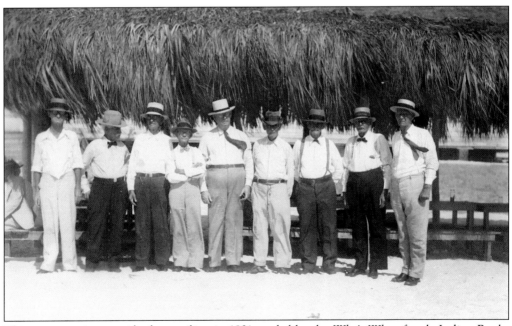

This group posing outside the pavilion in 1931 reads like the *Who's Who* of early Indian Rocks pioneers. They are, from left to right, Irving Meares, Jefferson Lowe, Harvey Hendrick, Dr. Bob McMullen, Ancel Walsingham, George Wesson Meares, unidentified, James Hardage, and Eli McMullen.

McMullen ladies enjoy a Sunday afternoon on the beach. The McMullens were another prominent pioneer family who continues to be active in Pinellas County. Brothers Robert and Donald McMullen headed the Indian Rocks Investment Company along with brother-in-law James Hardage. The group built the auto bridge in 1916. (Courtesy of Largo Library and Largo Historical Society.)

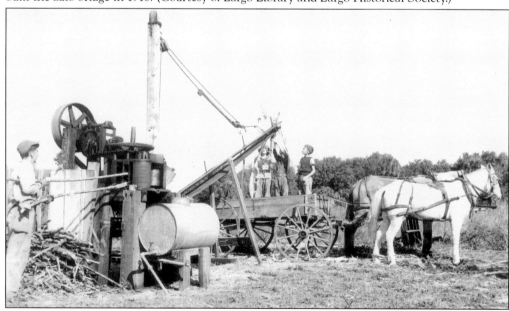
Florida cane syrup was a popular commodity produced by Angus McMullen at his Anona farm. According to a news account, visitors to the cane grinding operation could "drink the fresh, sweet cane juice to their heart's content." (Courtesy of Heritage Village Archives and Library.)

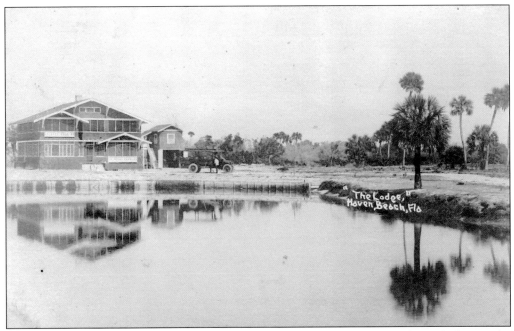

The Lodge, also known as the Haven Beach Hotel, was built around 1914 at the yacht basin. The structure originally served as a yacht club for wealthy Tampans and was converted to a hotel after development of the Haven Beach subdivision. It was the longest surviving of the old wooden hotels, being razed in 1992.

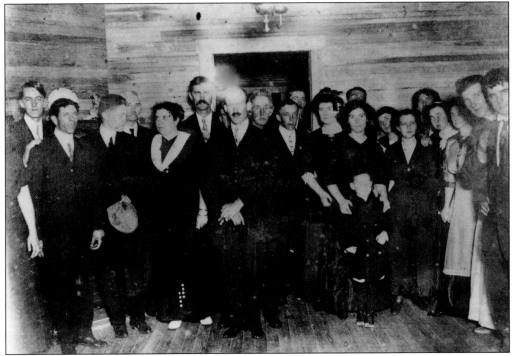

Members of a dance party at The Lodge gather for a portrait around 1915. The tall gentleman with a mustache in the back is a McMullen. (Courtesy of Largo Library and Largo Historical Society.)

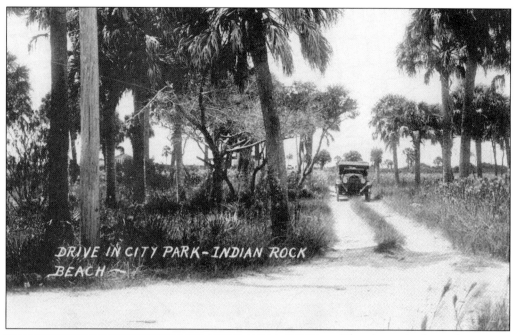

The city park, shown here in 1925, was the forerunner of today's Kolb Park, across from city hall.

A tranquil scene in the Narrows at Indian Rocks Beach includes boats tied up at Ross Johns Fish Market.

Two

FISHING

Fishing-related pursuits have played a dominant role in the development of Indian Rocks Beach since the days when migrant Native American tribes and Spaniards from Cuba vied for the sea's bountiful harvest. Pioneers told of catches so plentiful the fish would literally leap into their boats. Varieties taken were endless, with tarpon, jacks, mackerel, sea trout and, of course, mullet topping the list. Smoked mullet was a prized delicacy then as it is now. As might be expected, fishing became an important livelihood for many of the early settlers. Photographs dating from 1900 show members of the pioneer Hendrick and Meares families posing with large catches of mullet and tarpon.

The commercial fishing industry took hold in the early 1900s. Fish houses, markets, camps, and smokehouses lined the shoreline. Nets spread along the beach brought in loads of mullet and other valued species. Sport fishing also became popular, especially during the post–World War II tourist boom. At one time, seven fishing piers, private and public, jutted into the Gulf along Indian Rocks' shoreline. Most prominent was the Big Indian Rocks Fishing Pier, the longest in Florida.

Pollution, overfishing, and the installation of jetties to slow erosion limited the catch in later years, and by the 1950s the commercial fisheries had departed; however, sport fishermen remain a common sight along the shore, casting their lines and reeling in the catch of the day.

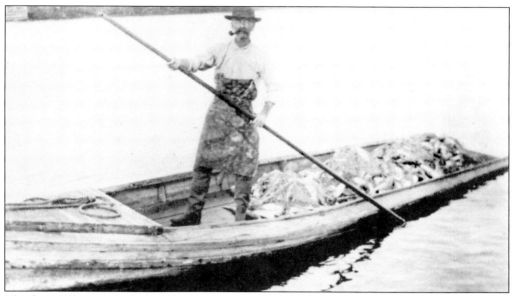

The first settlers in the Indian Rocks area turned to the seas for their livelihood. Here Harvey Hendrick, the barrier island's first resident, is shown around 1900 poling in with a load of mullet.

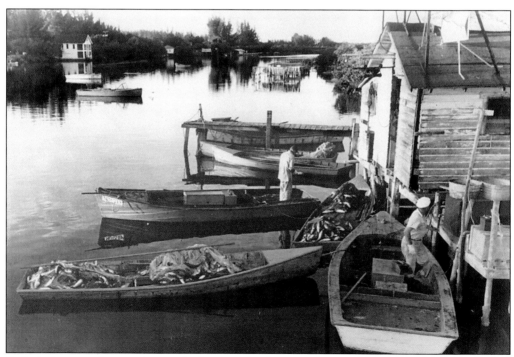

Early industry and recreation on the barrier island centered around fishing. Fish camps, such as Wyllys Ransom's fish house shown here on the right, were a common sight along the banks of the waterway. Note the boats loaded with the day's catch and the drying nets in the background.

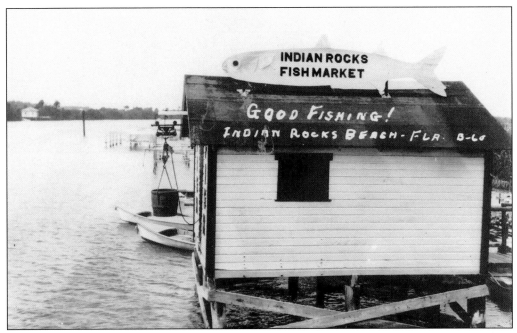

This sentiment penned on a photograph of Wyllys Ransom's fish house sums up the attitude of early island dwellers toward their most valuable resource.

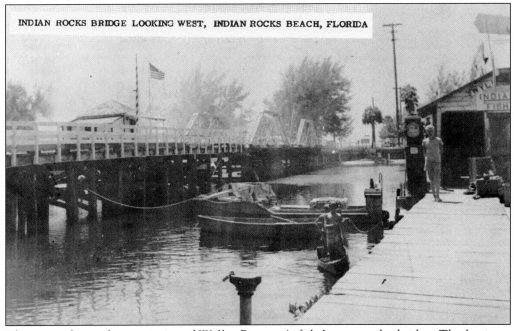

This view shows the proximity of Wyllys Ransom's fish house to the bridge. The business remained at its waterside location until 1957, when Wyllys Ransom opened his new fish market at 117 Gulf Boulevard.

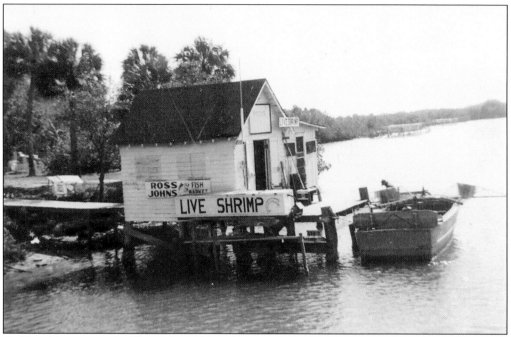

Gulf and bay waters bordering Indian Rocks provided a bountiful sea catch. Ross Johns Fish Market operated a competing fish market that was south of the bridge. The live shrimp were sold as bait to fishermen.

Mullet was prepared in smokehouses such as this one located outside Ross Johns Fish Market. Many people recall going across the bridge to Indian Rocks Beach and smelling the aroma of smoked fish.

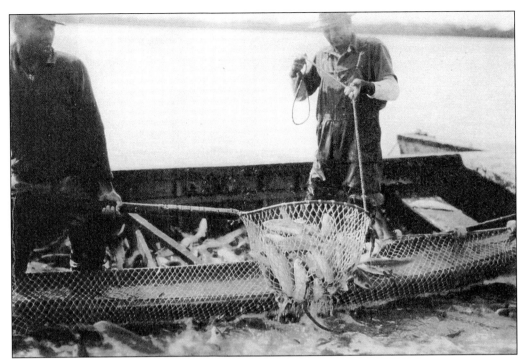

"The fish were there for the taking," one pioneer fisher remarked. When the bay waters were churning with fish, as in this scene, filling the boat became a relatively easy, though backbreaking task.

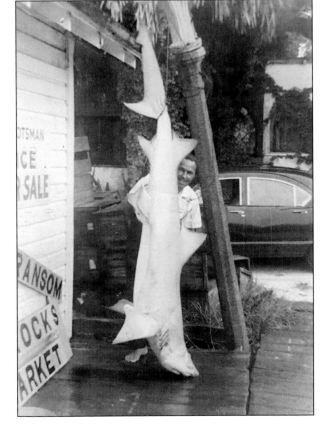

The Carter and Mai families also ran fish houses on the bay. Homer and Jo Carter built their camp at Eighteenth Avenue and Bay Drive in 1949. Gus Mai's fish camp was located on the east end of the railroad bridge, near today's Fifteenth Avenue. Here Fred Mai shows off a prize shark.

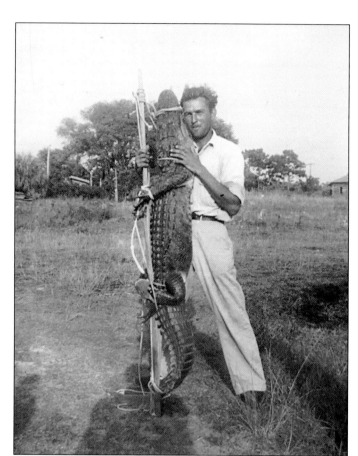

This alligator was subdued by Gus Mai near the Narrows around 1950.

Netting was a productive method of fish harvesting used along the Gulf shore until the construction of jetties in Indian Rocks during the 1950s stopped the practice. Often times beachgoers would stand and watch the process.

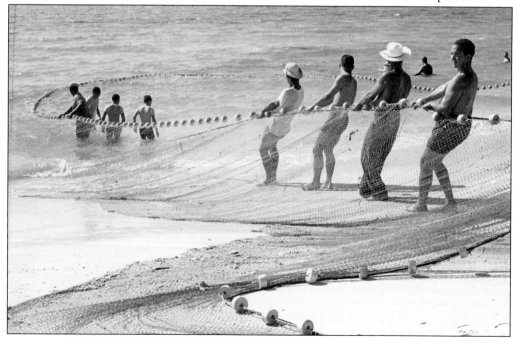

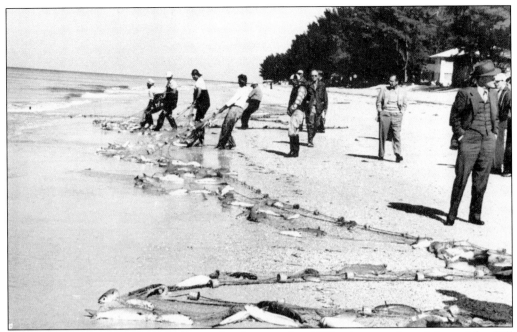

The booted fishermen hauling the catch ashore in this 1930s view are, from left to right, Bill Touchton, Guyan Meares, Wyllys Ransom, Fred Mai, and Holly Heisler.

The drying nets were once a common sight along the bay. This spot is just north of the bridge, across from the Indian Rocks Inn.

A bonus of living at the beach is having the makings of a seafood feast nearby and easy to procure. Here Coquina Cove trailer park resident Mrs. Newton shows off her string of sheepshead with a single trout.

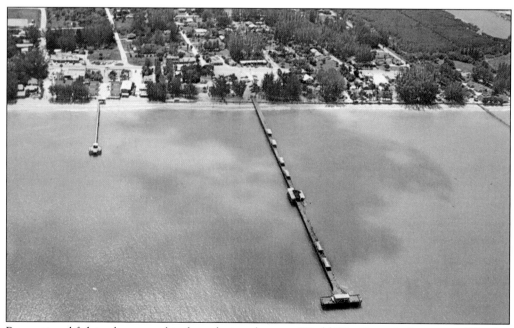

Recreational fishing became a big draw during the post–World War II tourist boom era. Wooden fishing piers were built along the beach to accommodate anglers eager to test the teeming Gulf waters. Shown here is the Big Indian Rocks Fishing Pier, constructed in 1959 by Carl Moseley and Louis Snelling. The longest pier in Florida, it served for 25 years as a center of community activity until it was taken out by Hurricane Elena's winds in 1985.

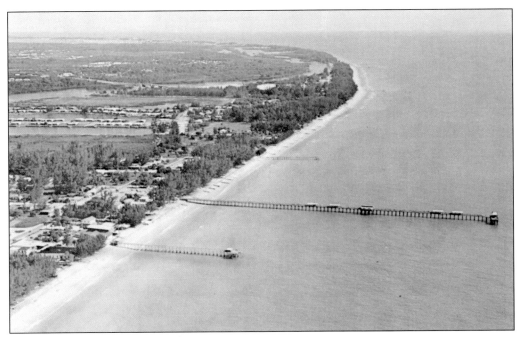

At one time, Indian Rocks was home to seven public and private piers, five of which can be seen here. The Big Indian Rocks Fishing Pier's length (1,040 feet) dwarfs the others.

FISHING

$1.00

Always Good Fishing

on the

INDIAN ROCKS FISHING PIER

Purchase Ticket Here

Benefit Chamber Commerce Building Fund

As this placard attests, fishing was cheap and good at the Big Indian Rocks Fishing Pier.

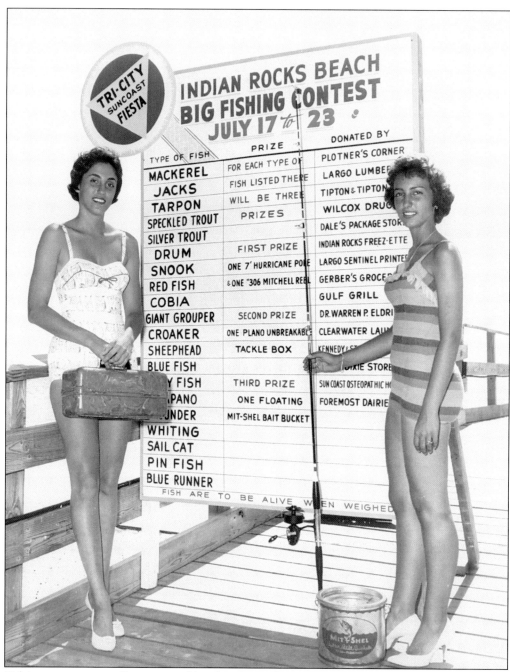

Fishing contests, usually sponsored by chambers of commerce, were held regularly to promote tourism and the local economy. These bathing beauties are publicizing the 1961 Tri-City Suncoast Fiesta. Note the number of fish species listed, and local businesses supporting the event.

Jim Slocum (center) and friends show off their catch of the day, which included "16 Reds, 1 Snook, 1 Lady," according to the inscription on the back of the 1962 photograph taken at the big pier.

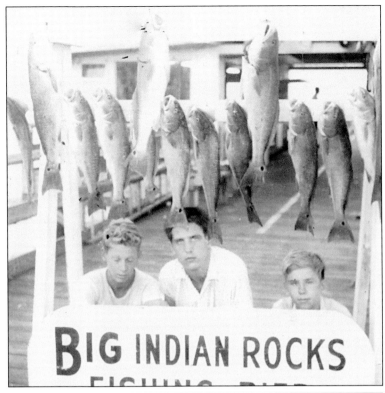

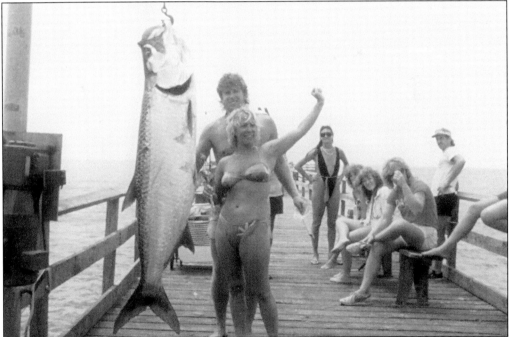

This couple shows off their prize tarpon caught at a fishing tournament on the Big Indian Rocks Fishing Pier in June 1985. Three months later the pier would be gone, a victim of Hurricane Elena.

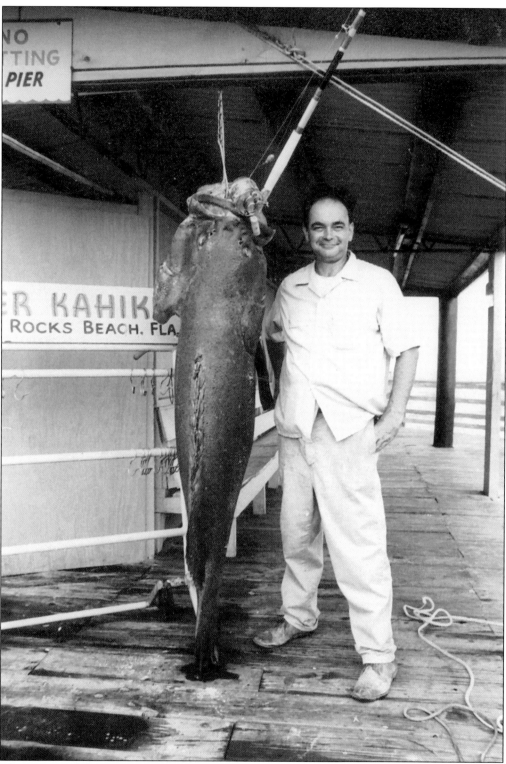
This giant jewfish (goliath grouper) was caught at the Tiki Gardens pier on the Gulf.

Three
GULF BOULEVARD

The beaches' main street started out as a series of unconnected sand trails cut through palmetto scrub. Until the barrier islands were bridged together in the 1920s and 1930s, each beach community had its own separate Gulf Boulevard. For many, the pathway provided the only land transportation route due to the narrowness of the island. Not until 1935, when Indian Pass in Indian Rocks Beach South Shore was filled in, did Gulf Boulevard become a continuous link from Pass-a-Grille to Sand Key.

At Indian Rocks Beach, the island's width was spacious enough to permit other roadways, which crisscross the city. But Gulf Boulevard was the main artery, where most businesses located and the community developed. The road in early times took a different route from today, partially passing along the shoreline. Photographs from that era show beachgoers parking their automobiles on the roadway before taking a dip in the Gulf.

The stretch was home to many memories, from the big-time attraction Tiki Gardens to local favorites like Brandon's Pavilion, Pueblo Village, Sam's Little Kitchen, the Hofbrauhaus, and so many others. Indian Rocks Beach is fortunate that high-rise condos have not completely dominated the west side of Gulf Boulevard, as in many of the other communities that lie along the beach strip. The thoroughfare is still home to locally owned firms, quaint inns, and residences that hearken back to an earlier day.

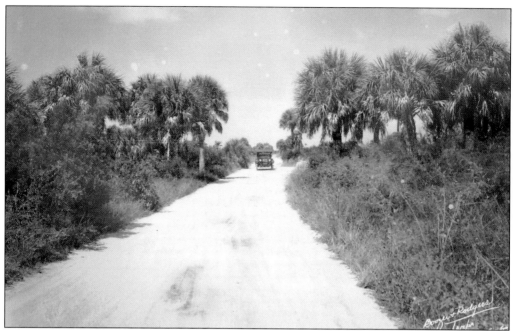

Gulf Boulevard tracks through a palmetto wilderness in this early view. The primitive trail provided the only access route along the barrier island and, in later years, became the main street, lined with businesses and accommodations.

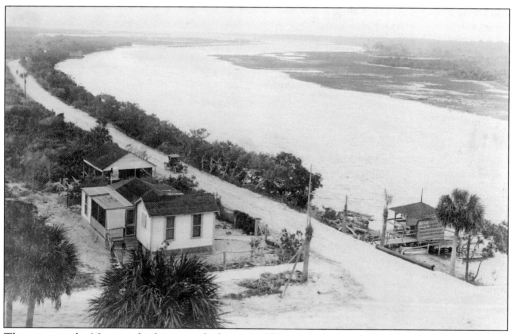

This view in the Narrows looking north shows Gulf Boulevard as a sand trail around 1915. In the foreground is the cottage annex to the Indian Rocks Inn. Hamlin's ferry landing can be seen on the water to the right. A boathouse can be spotted in the upper left. The Bie family still owns the landmark boathouse, which is used as a vacation retreat.

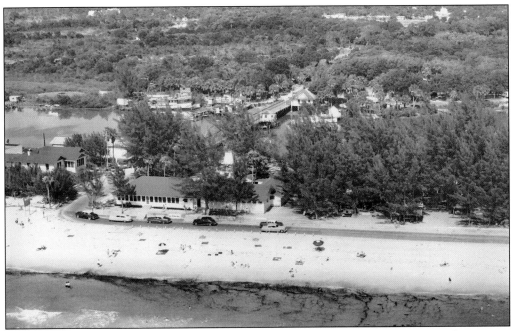

Parts of Gulf Boulevard ran directly along the beach until shore erosion forced a relocation to the present route in 1954. This 1950 aerial view shows development near the bridge. Brandon's Pavilion and the Indian Rocks Inn, at far left in the photograph, stood where the road jogged from the beachside to the bay side.

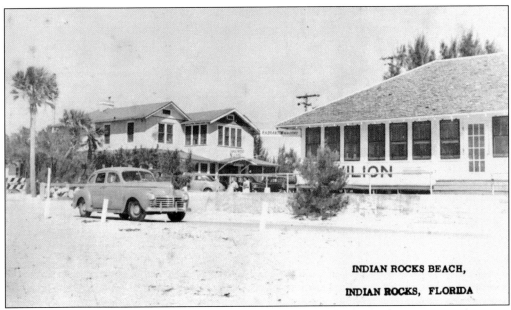

A closer look shows the roadway, which turned east toward the bridge here, running between the inn and pavilion.

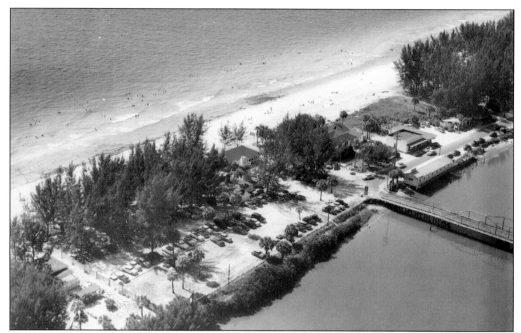

Australian pines were introduced to the area as a windbreak in the 1930s. They spread rapidly, crowding out native vegetation, and were the dominant foliage in Indian Rocks Beach until most were destroyed by freezes in the early 1960s. The combination post office/grocery to the right of the bridge is one of the few structures not surrounded by the trees in this 1950 photograph.

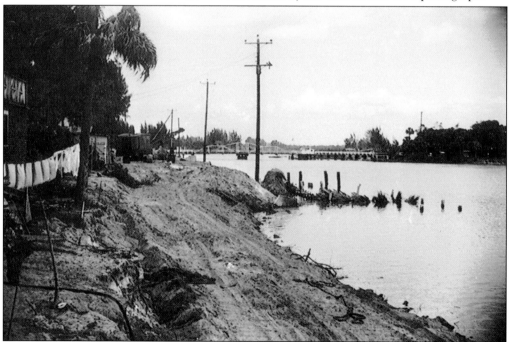

This 1954 photograph shows grading of the roadbed along the Intracoastal Waterway, south of the old bridge, in preparation for the rerouting of Gulf Boulevard. The crane is positioned behind Val Antuono's home, at the spot where he once had a swimming pool.

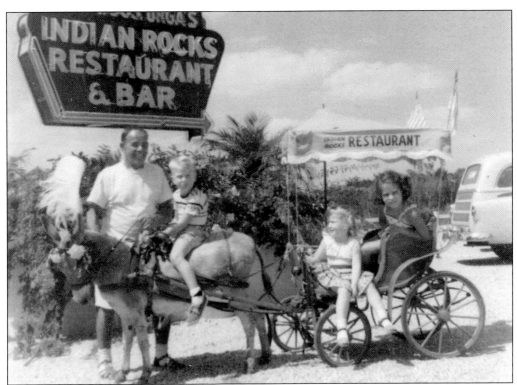

The tourist boom era following World War II saw the beginnings of many landmark businesses that contended for visibility along Indian Rock Beach's main street. Capt. Joe Urga introduced Liberace the donkey to call attention to his popular eatery, located at 19915 Gulf Boulevard. (Courtesy of Charles Foertmeyer.)

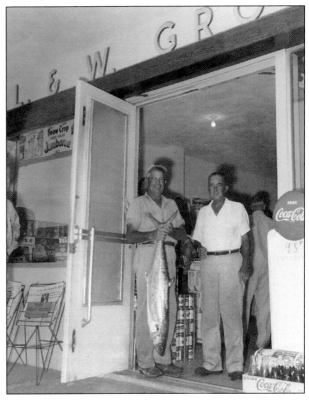

Fishermen often brought their catch directly to local food stores and restaurants. Filleted and packaged, this kingfish will be an enticement for shoppers at L. & W. Grocery (10 Gulf Boulevard) later in the day. Note the predicted high temperature of 95 degrees cleverly placed at the Coca-Cola display.

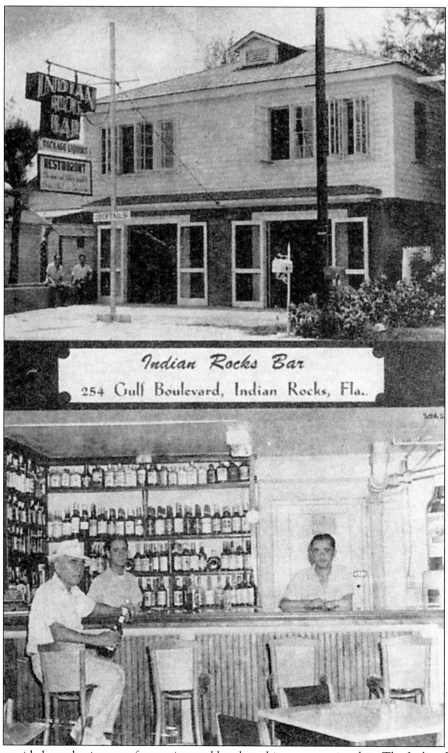

Bars provided a gathering spot for tourists and locals seeking companionship. The Indian Rocks Bar at 254 Gulf Boulevard offered "real Italian spaghetti along the beautiful Gulf Beaches."

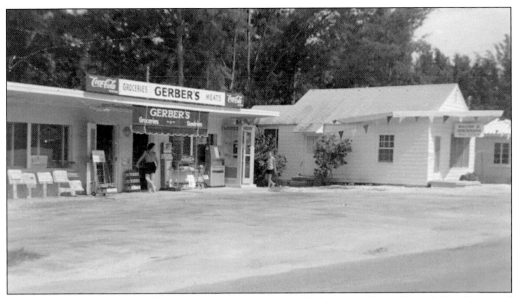

Beach retailers were independent operators, and their establishments often reflected the whims and personalities of their owners. Even today, chain stores are rare on the beaches. In the early 1950s, Mike and Berniece Gerber opened Gerber's Grocery at Gulf Boulevard and Thirteenth Avenue.

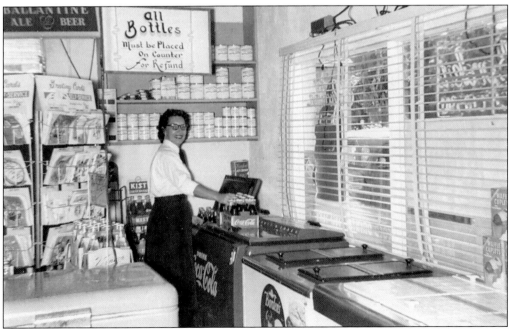

Gerber's, like other local markets, carried a variety of goods and functioned as an updated version of the classic general store. Virtually all soft drinks came in glass bottles, which were returned for refunds—an early example of recycling.

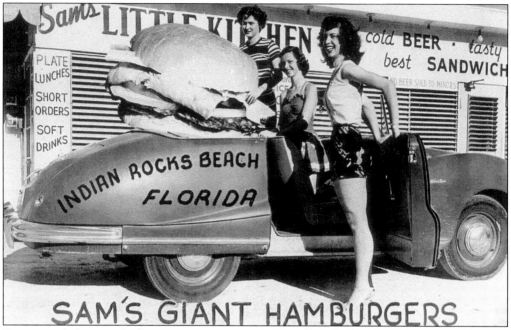

Promotional photographs featuring attractive women, usually in bathing attire, were a popular way to advertise beach businesses. Sam's Little Kitchen, located at 213 Gulf Boulevard, made extensive use of the concept. Owner Sam Morris's flamboyant style and outlandish promotions won him a loyal following among beachgoing locals and tourists. Johnnie and Irene Parker acquired the restaurant in the 1950s, renaming it Parker's Little Kitchen. (Courtesy of Jill Klein.)

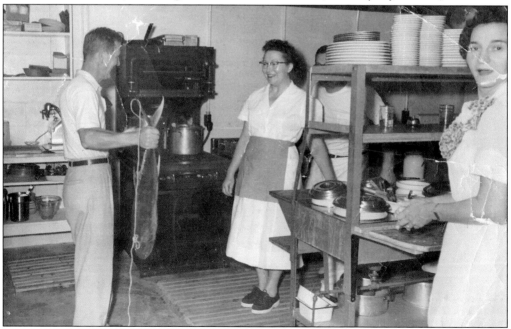

Johnnie Parker delivers the fresh catch of the day—with fishing line still attached—directly from the Gulf to the kitchen at Parker's Little Kitchen. Co-owner Irene Parker can be seen on the right.

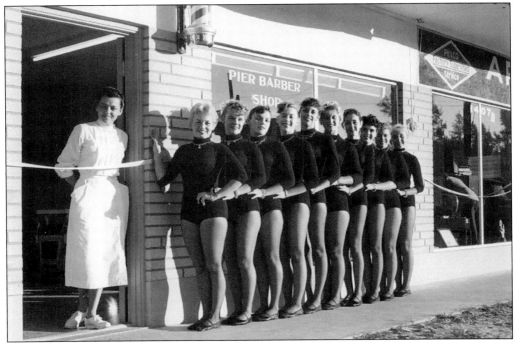

The Englandette Dancers, a local troupe, were employed to drum up business for the Pier Barber Shop, located at 1406 Gulf Boulevard.

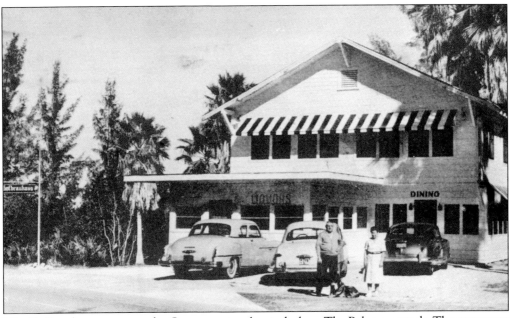

The Hofbrauhaus was a popular German eatery located where The Pub now stands. The restaurant had its beginnings in 1942 when Leo and Gertrude Smitz (pictured) bought the Beach Park, a small drive-in with two gas tanks in front. The Smitzes remodeled and expanded the original structure to create this landmark restaurant, which they operated until 1955.

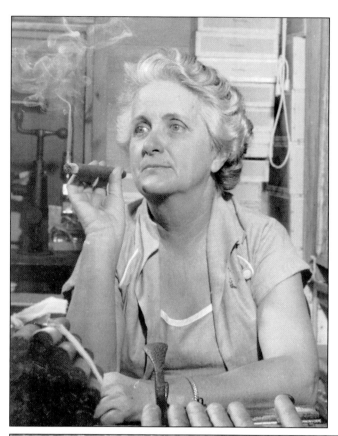

Hand-rolled cigars were made at the Harper Cigar Company, just off Gulf Boulevard at 19217 Whispering Pines Drive in Indian Rocks South Shore. Owner Estelle Harper is shown sampling one of her products, which were made exclusively from choice Cuban tobaccos. (Courtesy of Heritage Village Archives and Library.)

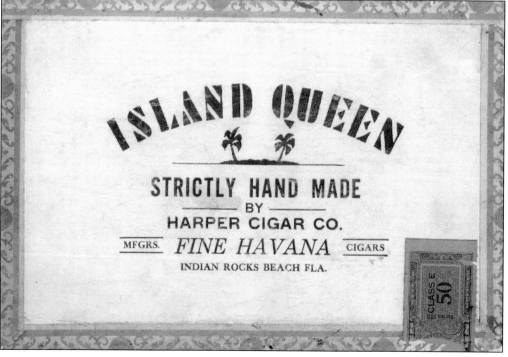

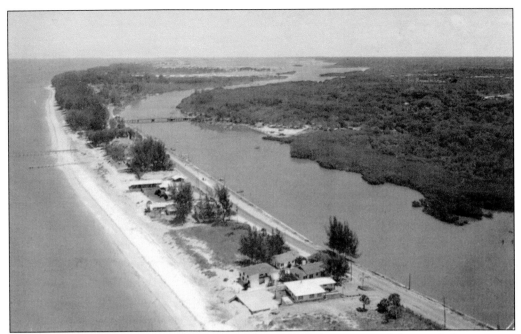

The Narrows south of the bridge escaped large-scale development until the condo boom hit in the 1970s. This aerial view, taken in the mid-1950s, shows a few residences and smaller motels, along with plenty of vacant land.

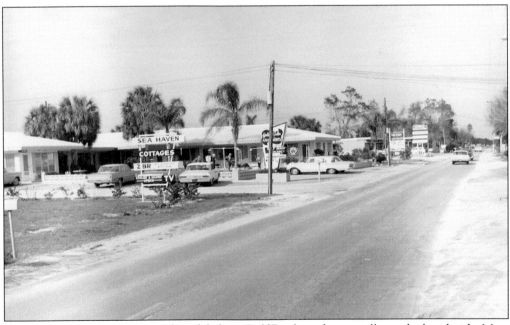

Tourist accommodations were plentiful along Gulf Boulevard, especially on the beach side. Most were the result of a motel building frenzy that took place in the late 1940s and early 1950s. This photograph taken near Twenty-second Avenue shows the Sea Haven Cottages of an earlier era facing competition from the newer Holiday Isles Motel, which boasts a shuffleboard court.

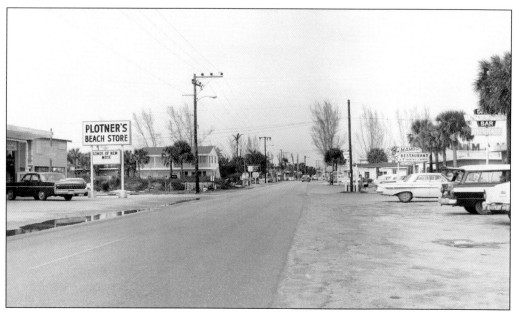

"Downtown" businesses clustered around the intersection of Fourth Avenue in 1962 include restaurants and bars, a gas station, beach sundries, a hardware store, and motels. The Mambo restaurant on the right was located where Crabby Bill's now stands.

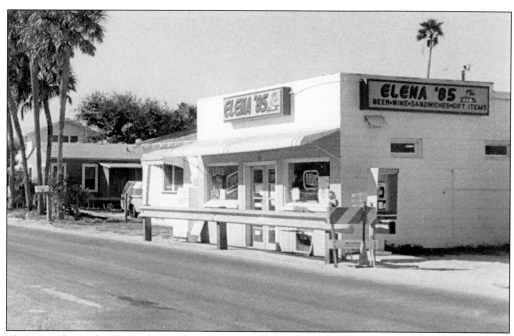

Elena '85, formerly the Little Food Basket, proudly proclaims its survival of the hurricane. The solidly constructed little building at 760 Gulf Boulevard has survived storm and development threats over the years. Recent occupants have been the Tacky Turtle and Kooky Coconut, both featuring authentic Cuban sandwiches.

Postwar prosperity and a dramatic rise in family travel during the baby boom era brought a surge in vacationers to the Gulf beaches. Vacant land was still available in Indian Rocks Beach for motel construction to accommodate this new growth market. This 1962 view from Eighteenth Avenue looking north shows lodging on both sides of the boulevard.

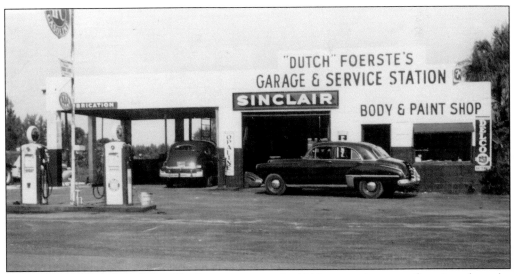

Development of a national paved highway system in the 1940s spurred a wave of tourism along the beaches. Dutch and Frances Foerste opened this service station and garage at 405 Gulf Boulevard around 1945 to take advantage of the emerging market.

Construction of the Walsingham Bridge in 1958 brought another population surge to the barrier island and paved the way for the condo building boom of the next decades. The bridge, seen in the distance from the intersection at Gulf Boulevard, was located about a quarter mile north of the old bridge. It was widened to four lanes in 1999.

Skeletons of Australian pines lost in the early 1960s freezes give a wintry appearance to this scene. Note the cottages and residences, which are predominant in this section of Gulf Boulevard north of Walsingham Road. The Haven Beach Hotel is in the distance at the middle of the picture.

Four

THE COTTAGES

In the late 1800s, Harvey K. Hendrick built the first home in Indian Rocks Beach. The island remained virtually a private enclave for the Hendrick family with not much more than scrub, hogs, raccoons, and a small trail. It was not until 20 years later that developers discovered the area.

Around 1916, the Indian Beach Company headed by Charles Lutz, C. H. Brown, and M. J. McMullen developed Indian Beach, the first subdivision on the island. About the same time, the Florida Beach Development Company undertook an ambitious project called Haven Beach, which included a distinctively T-shaped yacht basin and canal. The area gained prominence as "Tampa's playground" when large numbers of Tampa residents discovered the pleasures of beach living and began to build vacation homes to escape the summer heat and humidity of inland Florida.

By 1925, a variety of vacation homes had been built along the shores of the Gulf. As weekend and seasonal cottages grew in number, so did more permanent homes. Confidence and the economy improved after World War I, and with the use of aggressive promotions, land sales boomed.

By the 1940s, dredge and fill had created thousands of acres of additional waterfront properties available to the influx of new families seeking permanent homes after World War II. During this era, a variety of more modest wooden, stucco, and stone homes were built, giving the city its cottage character.

While permanent residents continued with the activities of daily life, visitors from inland and northern climates gained an interest in the rustic paradise, and many bought and maintained seasonal homes. Tourism and real estate continued to develop simultaneously. Beginning in the 1970s, many of the smaller dwellings and motels were demolished to make way for multistory condos and large waterfront homes, permanently changing the face of Indian Rocks Beach.

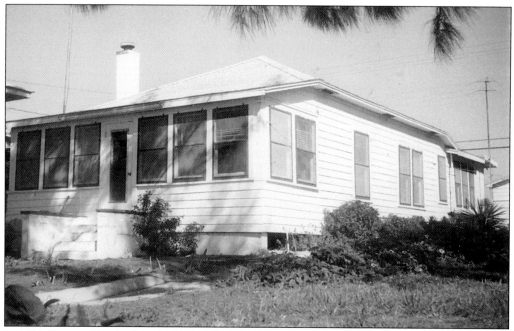

In 1891, Harvey Hendrick built the first house on Indian Rocks Beach. The Hendricks moved to the mainland in 1906, deeding their home to Charles Barnes, who sold it in 1924 to Mary and James Stanley for $3,700. It has a cistern to collect and store fresh water, a rare commodity before running water was brought to the island.

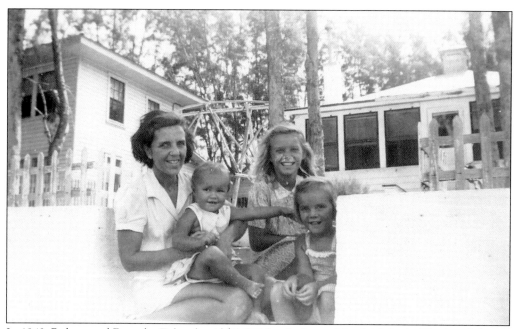

In 1942, Robert and Dorothy Zubrod paid $5,000 for the home Hendrick built. The beach house stands at 18 Gulf Boulevard. The Zubrod family still owns the house and uses it as a rental property and family retreat. They are seen here around 1950, sitting on the steps of the seawall.

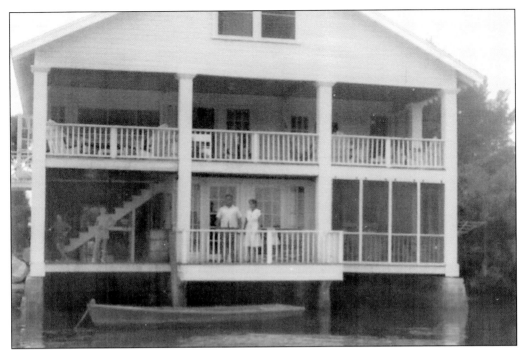

In 1911, Harry Ulmer, owner of Ulmer Citrus Groves, built this structure to house his speedboat *Miss Largo*. Norman and Rita Bie purchased the boathouse in 1938 and converted it into a permanent residence as well as a real estate office. It stands at 81 Gulf Boulevard aside, and partly over, the Intracoastal Waterway.

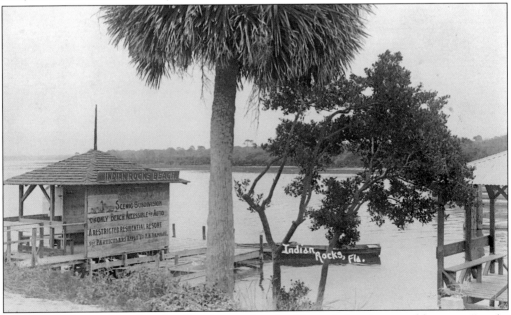

Horace Hamlin used his ferry landing site to advertise "the only beach accessible to auto" and a residential resort "where the surf sings you to sleep." Hamlin's Landing was located in the Narrows right beside Harvey Hendrick's crossing route from the mainland. In 1916, the bridge was built at this point, giving a boost to tourism and residential development.

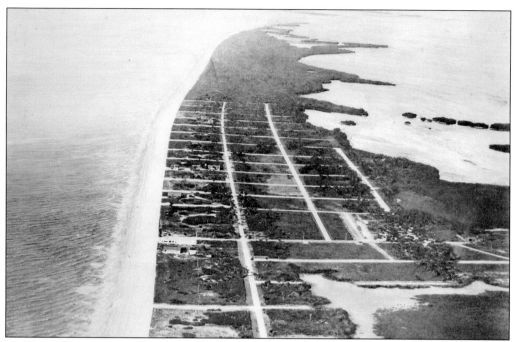

Residential subdivisions began in Indian Rocks around 1914. This photograph shows the first subdivision, Indian Beach, in the early stages of development. Indian Beach was centrally located in the area that today surrounds Kolb Park. The project consisted of a dozen or so houses and a hotel, which burned down in 1924.

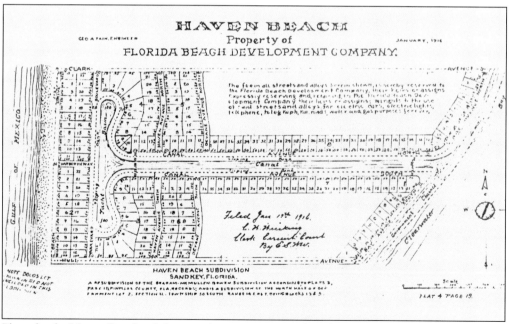

Plans for the Haven Beach subdivision drawn up in 1916 show lots platted across the island from the Gulf to the bay clustered around a central canal and yacht basin. The canal dredging had already begun when these plans were created, but lot sales were slow until after World War I.

George Fain, engineer for the Florida Beach Development Company, was responsible for designing the homes of Haven Beach. He is known for building second-story bedrooms with windows on three sides.

By 1925, most of the prime lots facing the Gulf and the yacht basin were populated; however, many homesites along the canal remained vacant and were eventually sold at sacrifice prices during the Depression years. At the north end of the yacht basin is the Haven Beach Hotel, which served as a yacht club for residents and excursionists arriving by sea.

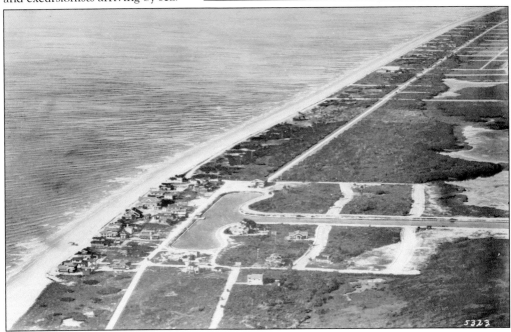

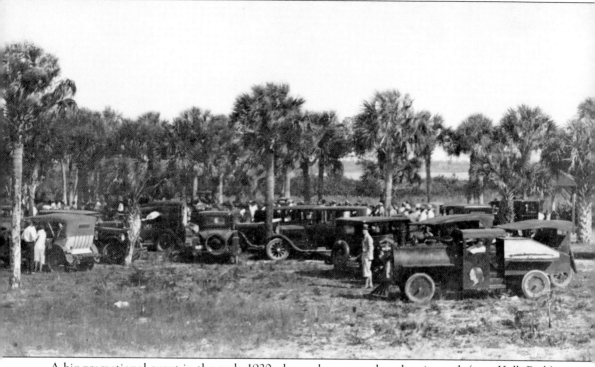
A big promotional event in the early 1920s drew a large crowd to the city park (now Kolb Park) for the sale of property in Indian Beach, the area's first residential subdivision. Lots were priced at $300 each. The 131 acres had belonged to C. H. Pomeroy, who acquired the land in 1908

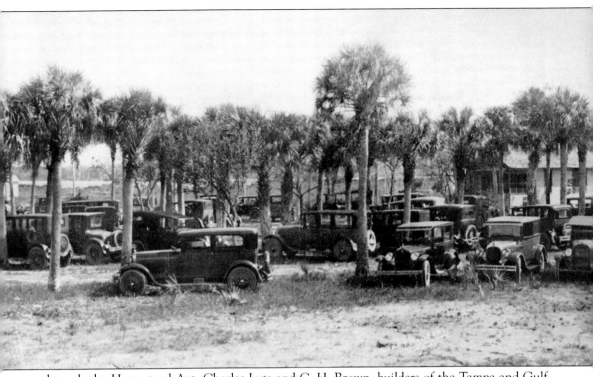

through the Homestead Act. Charles Lutz and C. H. Brown, builders of the Tampa and Gulf Coast Railroad, and M. Joel McMullen eventually purchased the land for $50,000 and founded the Indian Beach Company.

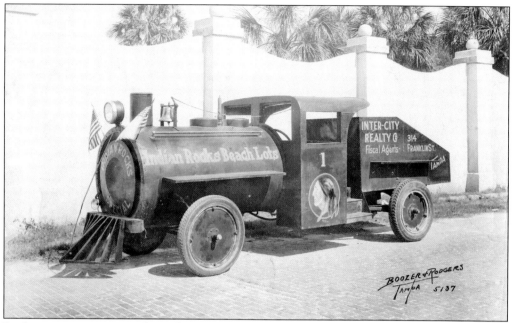

Real estate promotions involving "hot air" artists, binder boys, Airedale terriers, and German police dogs drew crowds to Indian Rocks Beach. On this day in 1925, the Inter-city Realty Company took their promotional vehicle to the fairgrounds in Tampa.

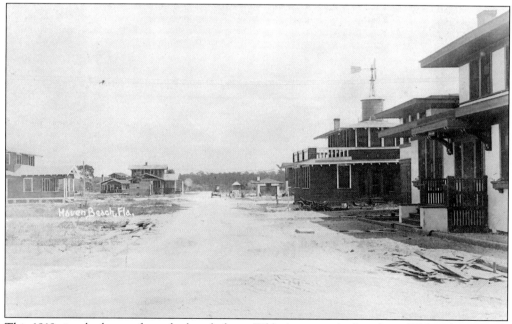

This 1918 view looks east from the beach down Fifth Avenue, which today is Walsingham Road. Many of the houses visible in this picture were summer homes owned by Tampa residents, but at this time there were few trees or plants to provide shade around the new construction.

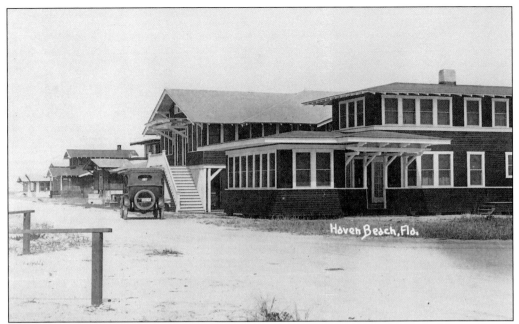

Tampan Carl O'Quinn, who was clerk of circuit court, built this large house in Haven Beach. Coming to the beach from Tampa before the bay bridges meant a long drive around the top of Tampa Bay and through Oldsmar. The trip most likely included a stop in Largo for a 50-pound cake of ice or two for the icebox at the beach house.

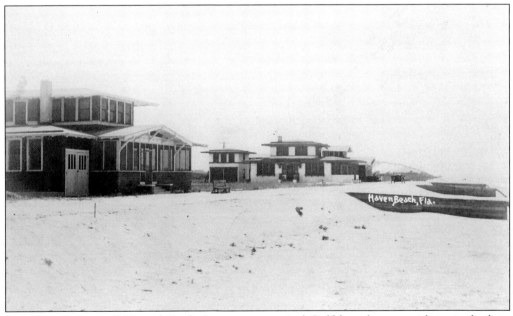

Stretching between Fifth and Sixth Avenues are typical Gulf-front homes, with jetties built in front to capture the sand and protect the beach. A promotional brochure from the 1920s gives this glowing description of the community: "Haven Beach is a thriving seaside home center where the man of moderate means may build a comfortable home amid all the pleasures of a high class resort."

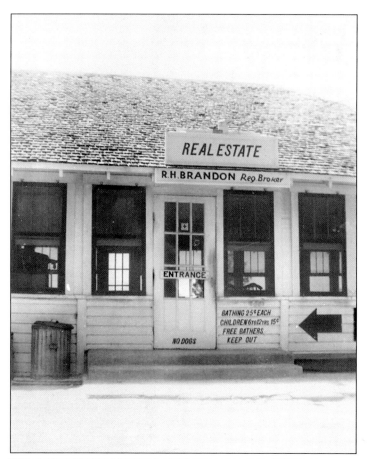

The pavilion served not only as a shop for snacks and souvenirs for beachgoers, but also as a real estate office for its owner, R. H. Brandon, a registered broker.

The summer home of Dr. Trice, a Tampa physician, was located at Indian Rocks Beach South Shore (now called Indian Shores). A windmill in the back pumped well water, which was used for household purposes like drinking, cooking, and washing. An old-timer says the wells yielded sulfur water that smelled like rotten eggs and turned silverware black. Some homes used electric pumps rather than windmills to draw the water.

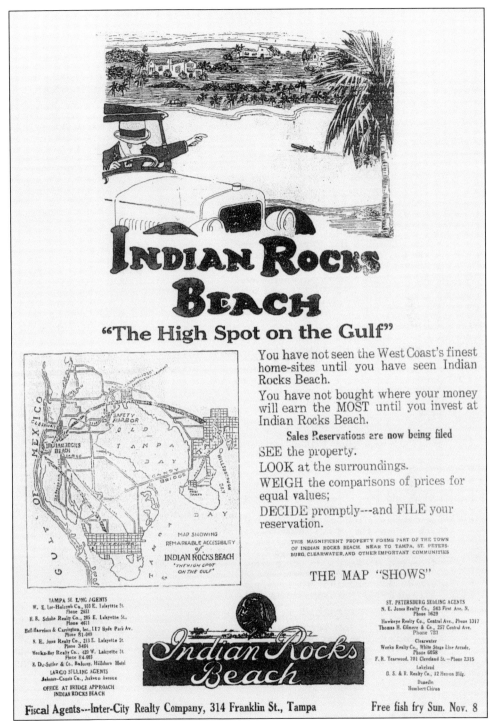

Indian Rocks Beach was touted in 1926 as "The High Spot on the Gulf," having the finest homesites on the West Coast. The Hawkeye Realty Company advertised 60-foot-by-100-foot lots on the South Shore at $8,000 or 90-foot-by-100-foot lots, double corner, for $13,500. Lots on the road were $2,750.

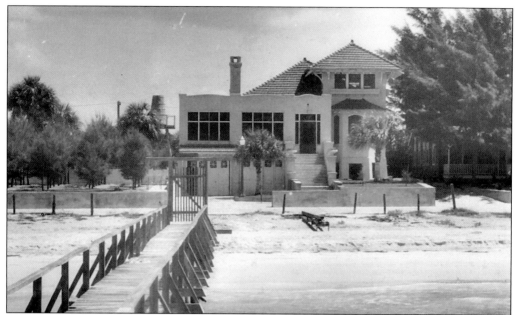

In 1910, Val Antuono constructed an elaborate summer home known as "The Castle." It had imported Italian tile, the first swimming pool on the beaches, and a private pier that extended into the Gulf. A primitive Gulf Boulevard ran along the seawall in front of the house. When the boulevard was moved in 1954, the backyard effectively became the front, and the garage was no longer facing the road.

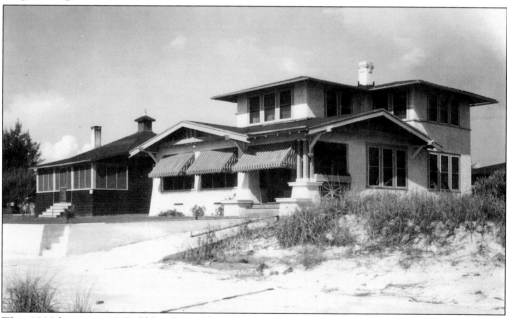

This 1920 home at 16 Gulf Boulevard has George Fain's hallmark second-story bedroom with windows on three sides. The original owner, B. T. Hines, died in 1928 leaving an estate worth $5,000. Manuel Garcia of Ybor City acquired the house in 1933 as a vacation retreat, and in 1945 the "Garcia House" was purchased by a lady who ran it as a boardinghouse. Next door is the Hendrick house, the oldest in Indian Rocks Beach.

The "Brown Bomber" was a 1941 Oldsmobile belonging to Jerry Harwood, a longtime resident. It is seen here parked in front of the house owned by Charlie Thatcher at the northeast corner of Walsingham Road (originally called Hull Avenue, then Fifth Avenue) and Gulf Boulevard.

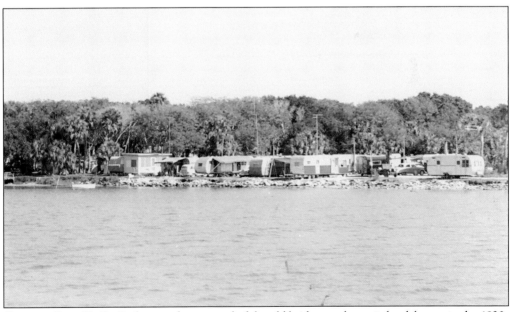

Coquina Cove Trailer Park, near the east end of the old bridge on the mainland, began in the 1930s and was reorganized after the war by Donald McMullen. Trailers served as a less expensive alternative for seasonal and local residents who wanted to live near the beach. The park is still in existence after more than 70 years. For many years there was also a trailer park in Haven Beach.

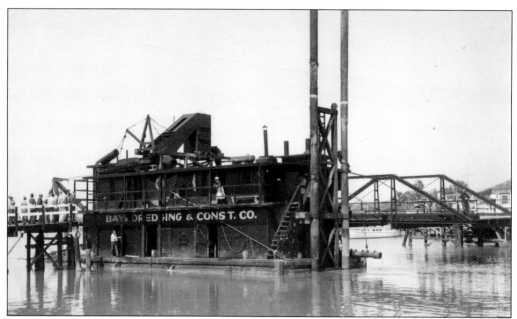

Dredging the bay began in 1938, creating fingers of land that would be sold as waterfront homesites. Robert and Laura Brown, as the Brown Development Corporation, owned property on the east side of Gulf Boulevard from Tenth Avenue to Twenty-eighth Avenue and expanded their holdings by the dredge and fill operations. Notice the bridge tender on the right and bystanders on the left in this photograph. (Courtesy of Heritage Village Archives and Library.)

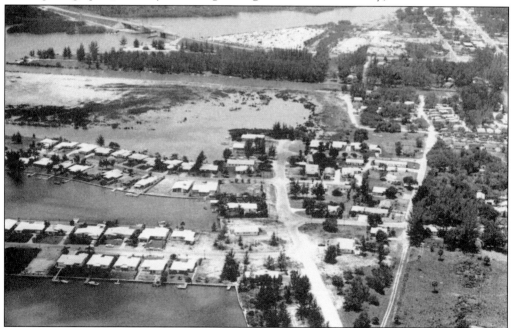

This late 1950s photograph shows the breadth of development along East Gulf Boulevard, Bahia Vista Drive, and La Hacienda Drive. The Bahia Vista subdivision, with its waterfront homes on newly created land, was begun in 1955. At the very top of the picture is the new Walsingham Bridge, which provided easy access to the growing community.

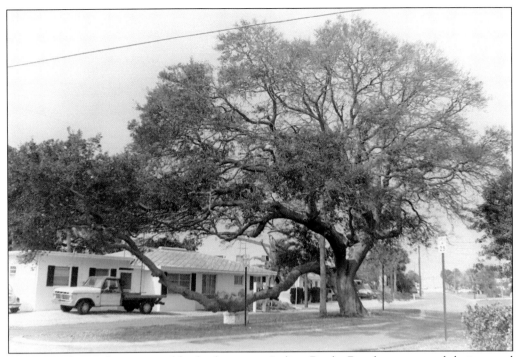

This spreading oak tree, possibly the largest in Indian Rocks Beach, was spared during road construction in the area. Developer Laura Brown decreed that Eighteenth Avenue should be split to run along either side of tree rather than removing it. The tree is still growing in the middle of the road.

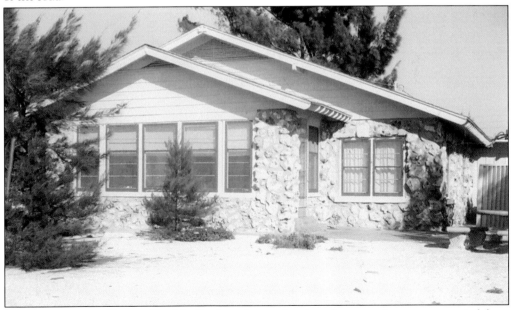

Local stonemason George Creel built charming and unique houses using stone quarried from the Peace River in Manatee County. The first stone house was built in 1937 as a residence for his family. He later constructed more than a dozen of these distinctive houses along Tenth and Twelfth Avenues in Indian Rocks Beach and eventually branched out across the country.

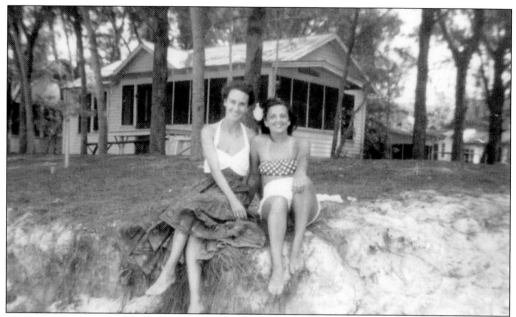

There were several cottages like this one along the beach near Twelfth Avenue that were built in the late 1930s. The small white wood-sided houses of this era were a distinct departure from the larger homes built by wealthy Tampans in the 1920s.

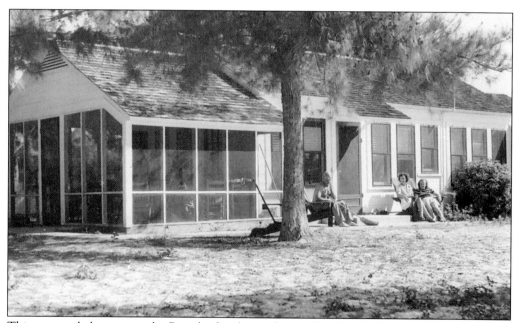

This cottage belonging to the Broeske family was located by the Gulf between Twenty-second and Twenty-third Avenues. It was a typical modest Indian Rocks Beach home, with a screened-in porch and Australian pines for shade.

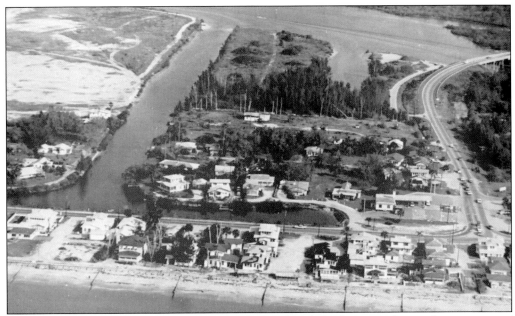

By 1964, a gas station (pictured lower right) had replaced the house at the northeast corner of Walsingham Road and Gulf Boulevard. Most of the old houses still remained, although many would eventually fall to new development when condos started to become popular in the late 1970s. With the new bridge open, Fifth Avenue became an extension of Walsingham Road and was now the main gateway to the beach community.

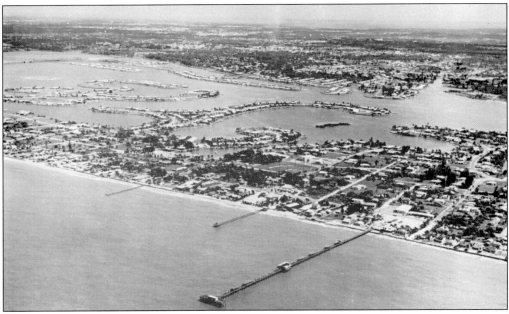

All the fingers had been created at the time of this picture in the 1960s. Construction moved northward to Twenty-seventh Avenue, where the Harbor Drive subdivision was built in 1951. Connecting streets in the neighborhood were named for members of the Brown family—Maxwell Place for developer Robert Maxwell Brown, Barry Place for his grandson, and Janice Place for his granddaughter.

An abundance of houses like the one shown here at 104 Fifteenth Avenue give Indian Rocks Beach its cottage character. This stone-block home is typical of those constructed during the building boom of the 1950s.

The Fifteenth Avenue house pictured above was built in 1956 for Olivia and Gerald Boza. This early photograph of the couple in their front yard shows the original screened-in porch, a must-have amenity in the days when cooling breezes served as air-conditioning.

Five

TOURISM

The tourist industry has provided a rock-solid foundation for the growth of Indian Rocks Beach. Local tourism got its start in the late 1800s, when Victorian excursionists would venture over to gaze at the barrier island's wonders. Curiosity spread, and rides on Harvey K. Hendrick's primitive ferry from the mainland increased. The pioneers' perception of the shoreline as a barren wasteland was changing.

Building the railroad spur to the island in 1914 and construction of the auto "rickety bridge" two years later provided access to the beach for thousands. Rustic yet spacious hotels sprang up to accommodate a new generation of beachgoers. Indian Rocks Beach's first tourist boom was launched.

By the 1920s, Indian Rocks had become Tampa's playground. The community's enduring cottage character was established by Tampans seeking a convenient getaway from big-city hassles and the summer heat. A popular gathering place was the pavilion, which offered beach sundries along with rental bathing suits. A mid-1920s postcard was labeled on the back with the following description: "Indian Rocks (On the Gulf), Unexcelled bathing beach, pavilion, restaurant, bath house, dancing, surf fishing. Come to Indian Rocks for a good time."

Tourism exploded in the years following World War II. War-weary ex-GIs packed up their baby-boom families and headed off for an extended vacation in the sun. Motels featuring television, air-conditioning, swimming pools, and drive-up accommodations replaced the cottages and hotels of an earlier era. The new generation was young and restless, looking for activities and attractions. Tiki Gardens, Pueblo Village, the Big Indian Rocks Fishing Pier, and "miles of silver sands" provided the answer.

The visitors apparently liked what they saw on vacation, and extended vacations became months long or permanent stays. Six-story Gulf-front condos began dotting the landscape in the 1970s, and new residents swelled the population of Indian Rocks Beach.

But the beach cottages, rustic inns, and homegrown businesses did not disappear. While Tiki Gardens and most of the motels are gone, today's tourists enjoy quiet Gulf-side stays at accommodations such as Colonial Court Inn, Sarah's Seaside, and Chic-a-Si Cottage, which have been restored to reflect the cozy charm of yesteryear.

Indian Rocks Beach's unique appeal and character caused *Boston Globe* correspondent (and part-time resident) Diane Daniel to rate this community the best beach in Florida, calling it "low-key, friendly and quaint in an un-manufactured way."

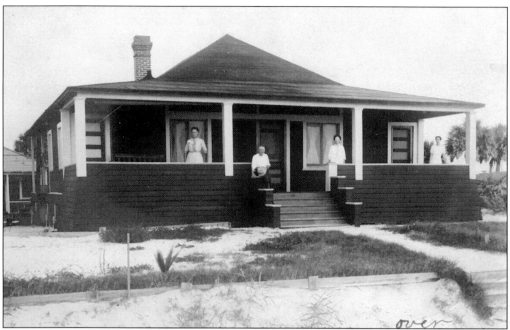

Indian Rocks' first public tourist accommodation, built in 1905, was the Knox Hotel. Shown here in 1910, it was one of the few structures on the island during the early years. This postcard describes Indian Rocks as "the place of the Gods." It is addressed to Dr. Robert McMullen, who was a builder of the swing bridge in the Narrows that opened in 1916.

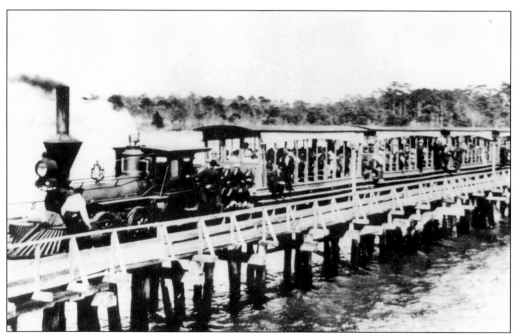

Building the rail bridge across the channel in 1914 brought the Tampa and Gulf Coast Railroad train, and loads of Tampa tourists, to Indian Rocks Beach. The primitive line was derisively referred to as the "Tug and Grunt," but it jump-started tourism along the barrier island.

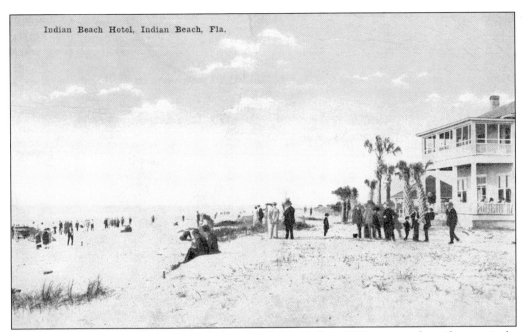

Samuel Pattison opened the 25-room Indian Beach Hotel about 1914 to serve the railway arrivals. A wooden sidewalk was built connecting the hotel to the rail spur in the vicinity of today's Kolb Park. The accommodations were popular, judging by the crowd.

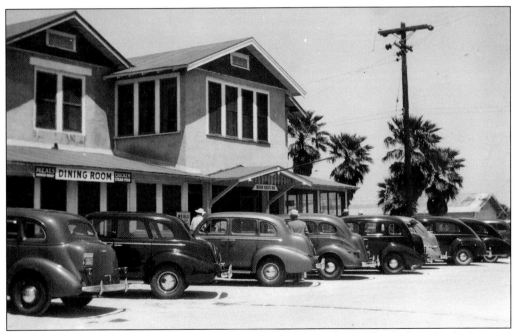

Early hotels were located near access points from the mainland. The Indian Rocks Inn was constructed in 1911 at the ferry crossing in the Narrows by Horace Hamlin, son of pioneer settler L. W. Hamlin. The opening of the auto bridge in 1916 assured its success. The inn had a long lifespan, finally succumbing to fire in 1963. This view was taken in the 1930s at the height of its popularity. (Courtesy of Heritage Village Archives and Library.)

Georgia Zubrod, whose great-grandparents owned the Indian Rocks Inn for many years, is shown here in 1941 taking a play break on the beach outside the inn.

As might be expected, most early tourist facilities were in the vicinity of the bridge. The top of the Indian Rocks Inn can be seen in the background on the right, behind the long building advertising the inn's dining room. To the left across the bridge is the pavilion bathhouse.

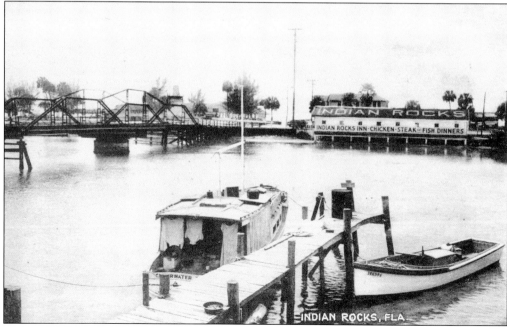

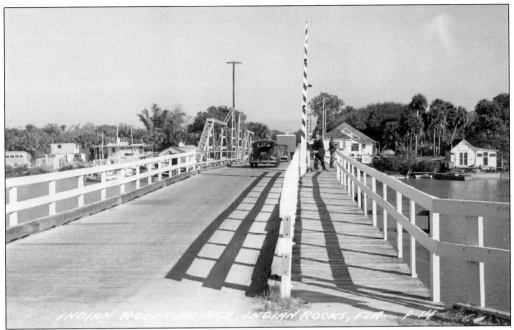

This 1940s view, looking eastward, shows traffic headed back toward the mainland. Note the bridge was barely wide enough to allow two-way traffic. Scrapes involving larger vehicles occurred at times, giving timid drivers genuine cause for fear.

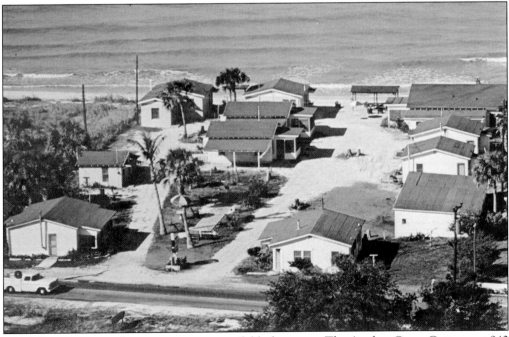

Beachfront cottages of various sizes were available for guests. The Anchor Court Cottages at 940 Gulf Boulevard all featured electric kitchens and access to a shuffleboard court. The Big Indian Rocks Fishing Pier was a nearby attraction.

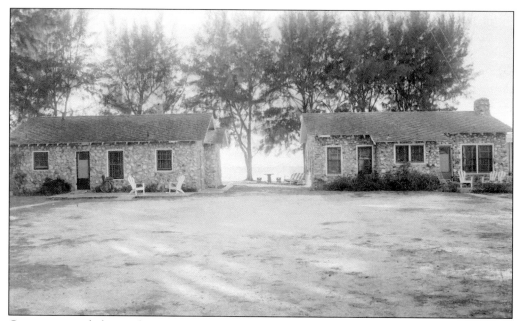

Cottages provided more living space than the hotels and appealed to guests on extended stays. The Piney Rocks Cottages, pictured here, were owned by W. O. Hodges of Plant City and were used for family retreats as well as monthly rentals. These buildings are examples of the classic stone houses built in the 1930s and 1940s by local stonemason George Creel.

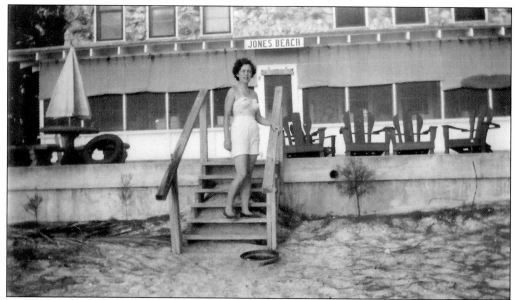

In 1946, George Creel built this larger stone house at 72 Gulf Boulevard in the Narrows. Shown here in 1956 as the Jones Beach Apartments, it originally housed The Rocks restaurant. Creel was known for constructing solid, well-built structures. Many of his stone houses remain standing, including this one, in Indian Rocks Beach and the vicinity.

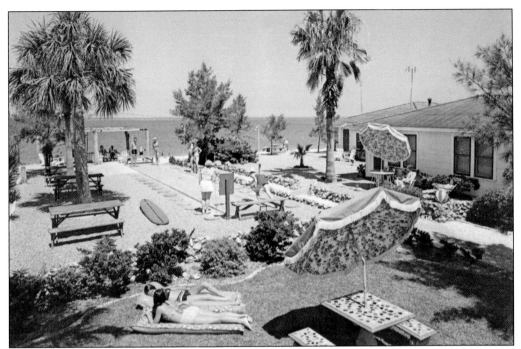

Shuffleboard courts were often among the amenities offered by family-oriented accommodations. The game was easy to learn and popular with all age groups. Guests often formed long-lasting friendships while competing at shuffleboard. This scene was at Windward on the Gulf, 2000 Gulf Boulevard.

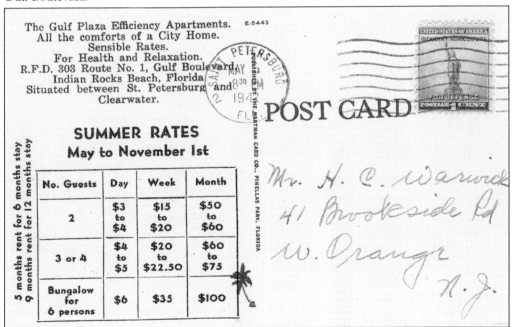

Rates at Indian Rocks Beach's motels and apartments were modest, and discounts were often offered for extended stays. The 1942 rates shown here for the Gulf Plaza Efficiency Apartments would not even pay the tax on stays at many properties today.

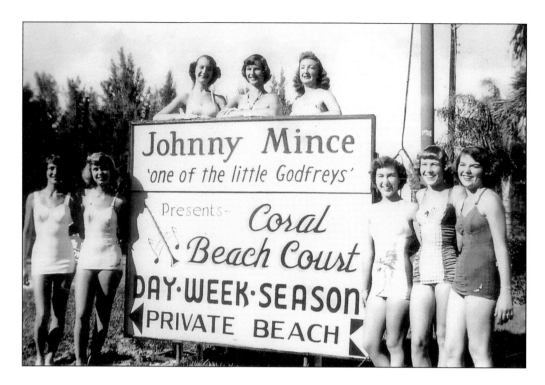

Big-name entertainment was not restricted to the larger hotels. The Coral Beach Court, a collection of modest cottages, featured performers such as the McGuire Sisters and radio and television star Arthur Godfrey's "little Godfreys." The cottages were former officer quarters at MacDill Field in Tampa, which were brought to this site following World War II. The photograph below shows the complex today as Uncle Milt's Courtyard at 701 Gulf Boulevard.

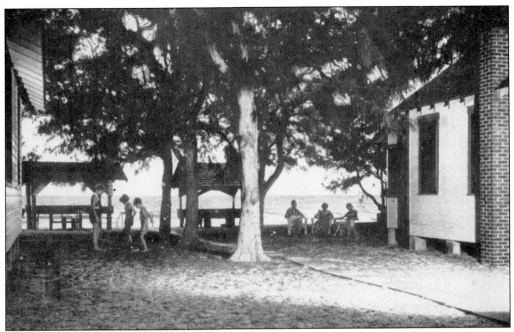

Creative Indian-themed accommodations set the Totem-In apart from its neighbors. The nine rental cottages were owned and managed by Claire and Leah Nicodemus. Claire carved the totem poles placed throughout the property. The resort was located at 19906 Gulf Boulevard.

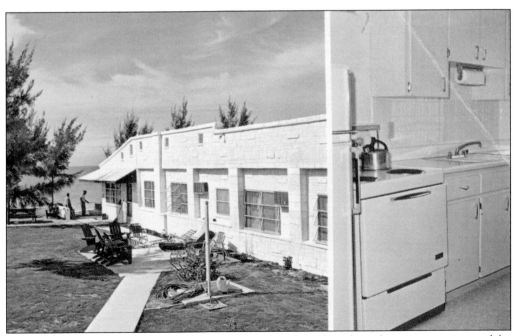

The Casa Blanca Apartments at Fifteenth Avenue and Gulf Boulevard were a conversion of the former APMAT (Tampa spelled backwards) Club. The club served in the early years as a social gathering place for the many Tampans who vacationed at Indian Rocks Beach. At some point the building was converted to two-room apartment units, which offered full kitchens.

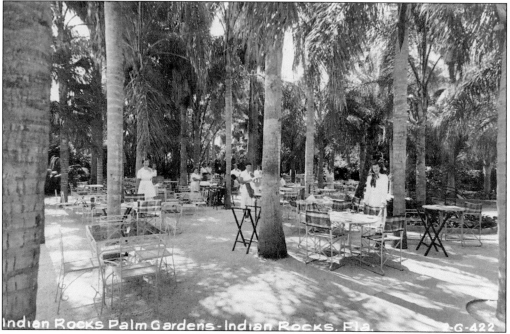

For a special night out, diners often chose Harry Ulmer's exotic Palm Garden Restaurant, located at the corner of Indian Rocks Road and Walsingham Road, where Walgreens now stands. The Palm Garden featured outdoor tables for "dining under the palms."

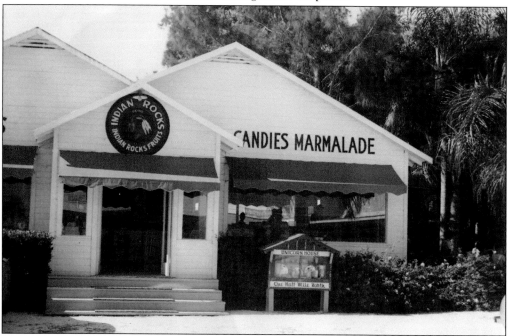

Opposite the Palm Garden Restaurant was the candy kitchen, where Marion Soderquist supervised the preparation of Indian Rocks brand homemade candies and preserves. Both operations were part of the Indian Rocks Fruit Company, whose groves covered the surrounding area. (Courtesy of Largo Library and Largo Historical Society.)

Colorful and distinctive shipping crate labels were used to clearly identify the growers' brands. They were also an effective marketing tool in an age when branding was a mark of quality. The Indian Rocks Fruit Company sold citrus under the Indian Rocks, Sonny, and Sonny Boy labels.

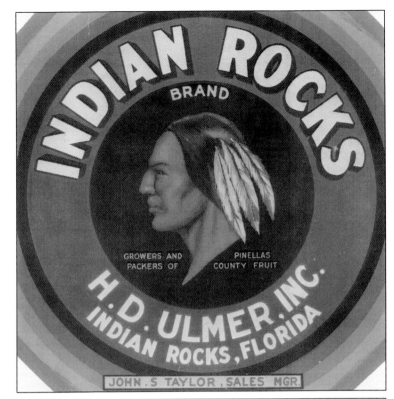

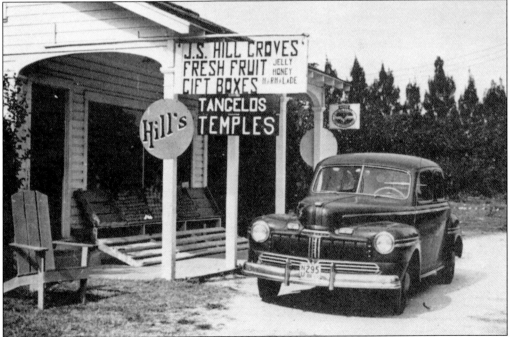

J. S. Hill Groves packing plant and retail store on Oakhurst Road provided another opportunity for visitors to stock up on Florida citrus or send a gift box to friends and family back home. The building today is a private residence.

In addition to sun and surf, Indian Rocks Beach had special attractions to keep its visitors occupied. The pavilion bathhouse offered nighttime dancing and entertainment, along with sundries and Coca-Colas for beachgoers. The building served as a teen nightclub in its later years, before burning to the ground in 1963. It is shown here in 1950.

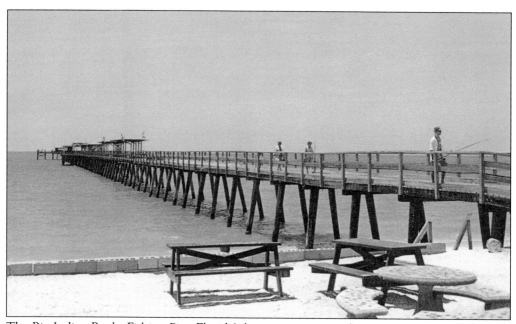

The Big Indian Rocks Fishing Pier, Florida's longest, was a noted tourist attraction. Fishermen would haul in record catches from their favorite spot along the railing, while sightseers enjoyed walking the pier's length to capture "out at sea" vistas.

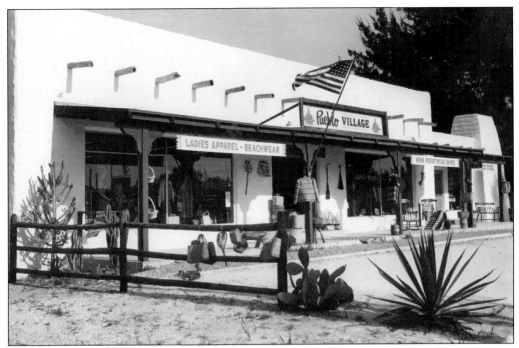

Pueblo Village drew tourists and locals for over 40 years. Its Western-themed adobe was located at Fifteenth Avenue and Gulf Boulevard. The popular enclave offered an eclectic mix of apparel, merchandise, and food items, and its memory has remained a part of local folklore. A condo development now occupies the site of Florida's Wild West connection.

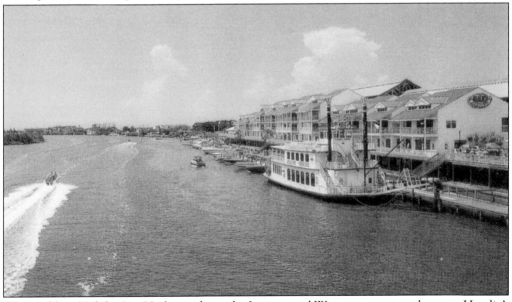

The rambling Holiday Inn Harbourside on the Intracoastal Waterway was once home to Hamlin's Landing, a regional tourist venue featuring shops, restaurants, and lodging. The *StarLight Princess* local cruise boat was first based here. The complex was converted to mostly accommodations after several years of operation. In 2005, the property was extensively renovated to become a condo hotel.

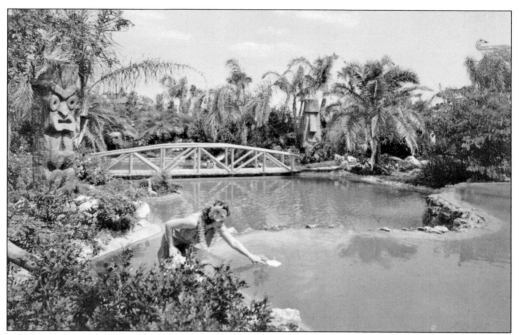

Tiki Gardens was a nationally acclaimed Polynesian paradise featuring jungle trails through lush gardens, lagoon boat rides, exotic bird shows, gift shops, and the famous Trader Frank's restaurant. Twilight torch-lighting ceremonies were presided over by the ever-present tikis. The attraction drew over 300,000 visitors annually during its heyday years in the 1960s and 1970s.

Owners Jo (left) and Frank Byars, shown here with a hostess for Trader Frank's restaurant, created Tiki Gardens in 1964 after their Signal House gift shop on the site burned to the ground. The Byars decided to expand a small garden area in back of the shop and create an attraction that would take advantage of the Polynesian craze sweeping the country at that time.

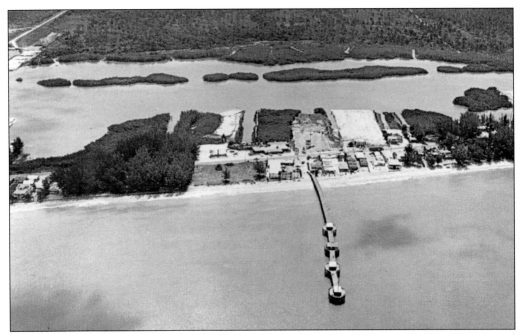

This aerial view shows Tiki Gardens under construction along the Intracoastal Waterway. Jutting into the Gulf along the beach is the Kahiki Pier. (Courtesy Heritage Village Archives and Library.)

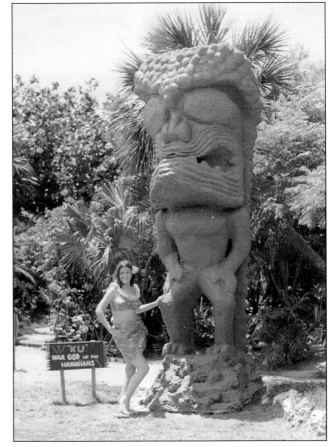

The tiki creations, such as Ku the war god, were authentically researched and recreated by the Byars. There were 10 themed gift shops in the gardens specializing in exotic South Seas merchandise, placing Tiki Gardens a level above the more kitschy Old Florida attractions.

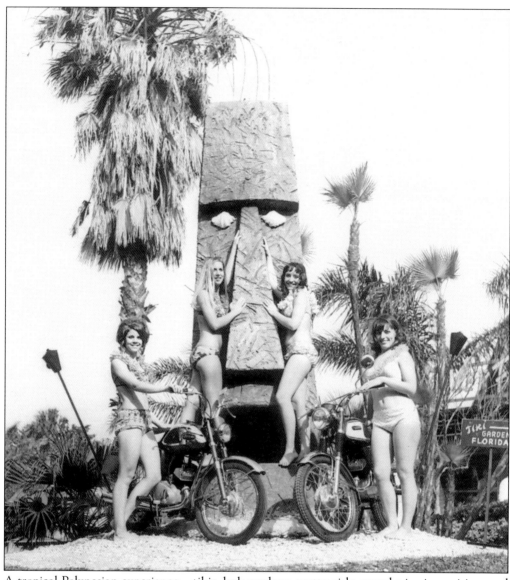

A tropical Polynesian experience—tikis, lush gardens, pretty girls, award-winning cuisine, and unique shopping—gave Tiki Gardens a cachet and mystique that endured over three decades. The attraction survived and prospered despite competition from Busch Gardens and the Disney parks. The end came in 1992 after the Byars sold the gardens to a group of Australian investors, reportedly for a treasure in opals.

Six

BEACH LIFE

The 3-mile strip that is Indian Rocks Beach was mostly vacant land even into the early 1950s, with not too many young people or children around. Restrictions were few, and the children who were there could run around with a great deal of freedom. There were few businesses, mainly mom-and-pop type affairs such as Ross Johns Fish Market, where mullet could be bought for about 5¢ a pound. Mostly mangroves and small buildings stood between this little beach settlement and Clearwater. The bay was flat and clear, providing good fishing.

There was quite a colony of Tampa people who owned cottages on the island. When school ended, the families took off for the beach, cars loaded with clothes, bedding, groceries, and kids. Much of this was reported in the *St. Petersburg Times*, with notations such as "Mr. and Mrs. J. Herring are occupying the Blackman cottage on Haven Beach for the rest of the summer." Some families brought their cooks with them.

The sandy white beach has always been the main attraction at Indian Rocks, where swimming and fishing and soaking up the sun were and are the favorite activities. In those earlier days, bonfires and wiener roasts as well as horseback riding were permitted on the beach. There were piers that provided an alternative to shore fishing. Sundry shops, bars, groceries, and restaurants were available, but beyond that, locals went to the mainland for shopping and entertainment.

In Indian Rocks Beach everyone seemed to know everyone else, and residents depended on volunteer-run events and fund-raisers for social activity. During the winter months, full-time residents dealt with the influx of northerners escaping the cold climate. The population swelled, restaurants got busy, and motels filled. That has not changed much, although the community has grown from a few inhabitants to a densely populated resort area with 5,000 residents. The laid-back island life is still appreciated and promoted in "IRB."

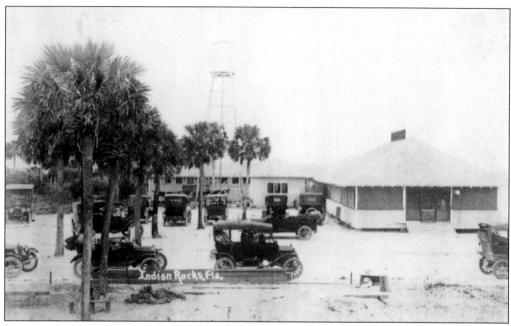

For many years the pavilion, seen here in 1919, served as the center of social activity. Its location on the beach, right at the end of the bridge, made it a natural gathering spot for family reunions, picnics, dances, and civic events. (Courtesy of Heritage Village Archives and Library.)

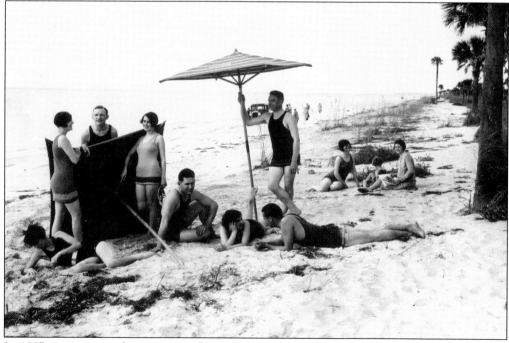

In 1927, as now, people came to Indian Rocks to enjoy the beach. Bathers are seen in this photograph wearing unisex outfits. Men were banned from baring their chests until after World War II. (Courtesy of Florida State Archives.)

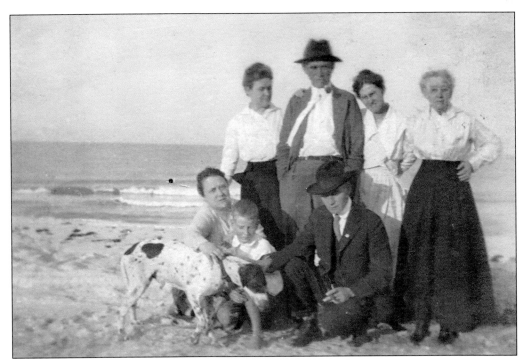

This 1919 photograph shows the family of local architect George A. Fain standing on the beach in business suits and ties and the typical daily dress of the era. The beach was more popular for sightseeing and picnics in those early days than it was for swimming and sunbathing.

Mary Ruth Fain Bolles is pictured beside the canal created by her father at Haven Beach. A long dress with long sleeves and a hat protected the wearer from the sun.

A group identified as Dr. L. M. McMullen, Francis and Lucy, and Mr. and Mrs. George Thorne had their picture taken on a winter day at the beach around 1914. Going to the beach was a popular weekend excursion.

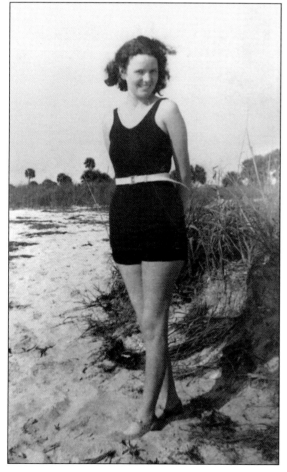

This bathing beauty, wearing a typical bathing suit of the era, poses for a picture in 1930 on Indian Rocks Beach. She is Annie Lou Dean Fields of Largo, whose family owned Dean's Men's Wear. (Courtesy of Largo Library and Largo Historical Society.)

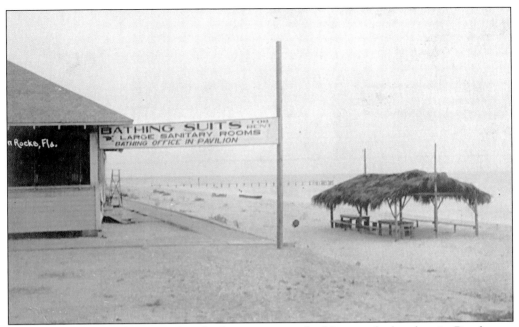

Built in 1915, the pavilion served as the first community building on the beach strip. Beachgoers could buy snacks, rent swimsuits, and change their clothes in "large sanitary rooms," then lie in the sun or take a dip in the Gulf.

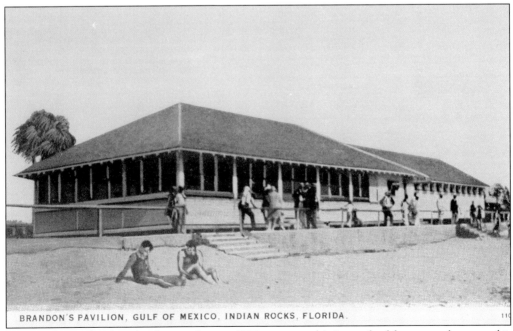

Raymond Brandon bought the pavilion in 1921, converted it into a bathhouse, and operated it until 1956. In the 1960s it became the Turtle Club, a beach club for young adults. The end came in 1968, when the building, already in disrepair, was destroyed by fire.

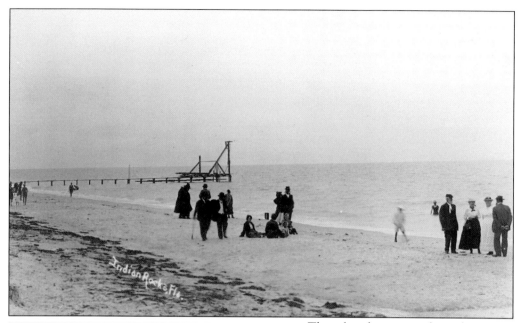

These beachgoers are dressed in excursion attire—suits and ties and long dresses—as they stroll the beach. On the left is a pier under construction, most likely at Val Antuono's home just south of the pavilion. None of the old piers that stretched into the Gulf along Indian Rocks' shores exist today.

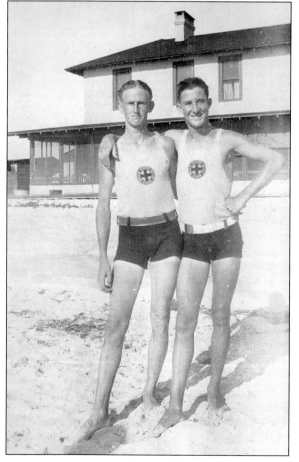

Two lifeguards are seen here in the 1920s posing for a photograph in front of the Indian Rocks Inn. On the left is Henry Whitesell, a member of a prominent Largo family. The Whitesells donated land for the Whitesell Softball Complex near Heritage Village.

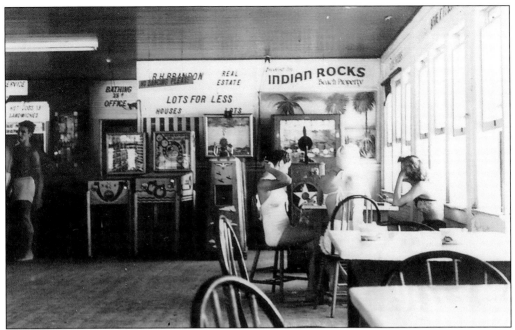

At Brandon's Pavilion in 1947, a person could rent a swimsuit, bathe in the Gulf for 25¢, or contract to buy property in Indian Rocks Beach from R. H. Brandon, who based his real estate office there.

The pavilion was also a good place for quenching thirst or getting a sandwich for lunch following a morning swim in the Gulf.

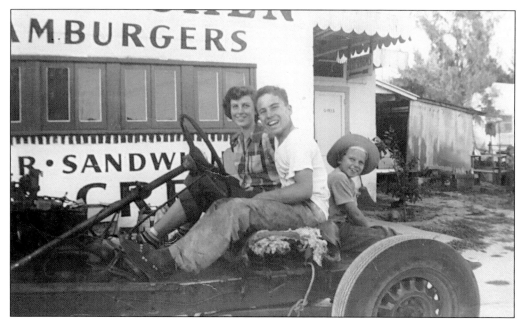

Shera Haight, 17, and Billy Bie, 18 (with Starr Haight in the back) take a ride in Billy's hot rod to Sam's Little Kitchen. A date for local teenagers living on the beach might include a drive over the bridge to watch a movie at the Capital Theatre in downtown Clearwater.

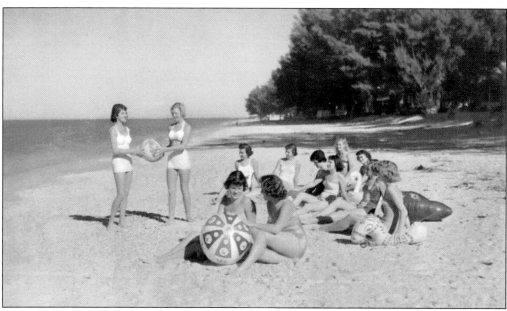

A group of local girls poses for this postcard scene on Indian Rocks Beach. Standing with the beach ball are Joyce Meares (left) and Pat Randall and sitting in front are Tania Olson (left) and Donna Cornwell. At the time this photograph was taken in 1952, the beach was prolific with fast-growing Australian pine trees.

Bill Brandon grew up on Indian Rocks Beach, where his father owned the pavilion, or "Bath House," as it is called in this 1950s photograph.

This tranquil scene includes a view of Gulf Boulevard, which runs beside the seawall, and the pavilion in the distance. Note the drying racks for fishnets, and the price of beer at the Indian Rocks Tavern, built by Val Antuono around 1937. (Courtesy of Heritage Village Archives and Library.)

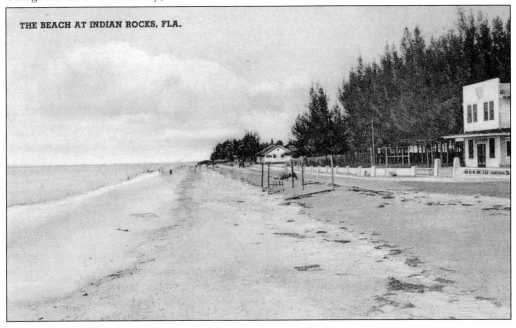

THE BEACH AT INDIAN ROCKS, FLA.

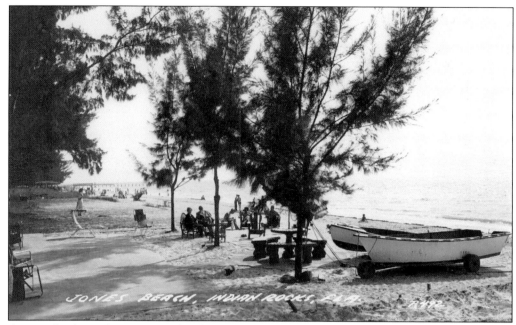

Among the Australian pines in the Narrows was Jones Beach, where local and seasonal residents gathered to socialize, picnic, and swim in the 1940s and 1950s. Owner William Jones served as the city's first mayor after the 1955 incorporation of the city.

When Gulf Boulevard ran on the west side of the island, tourists had convenient access to the beach by car. Eventually the road was moved to the east side, and public access was limited. Today Indian Rocks Beach provides public access at almost every avenue, allowing more right-of-entry to the beach than any of the other barrier island communities.

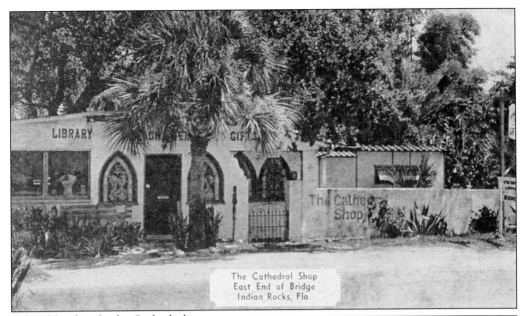

The Cathedral Shop
East End of Bridge
Indian Rocks, Fla.

A local landmark, the Cathedral Shop—so named because of its stained glass windows—was built by Horace Hamlin at the east end of the old bridge. It was run by Marian Ray, wardrobe mistress for the Ringling Brothers Circus and maker of the shell jewelry sold at the shop. After a move to the corner of Gulf Boulevard and Fifth Avenue in the 1950s, "fashionable" ladies apparel and beachwear was added to the inventory.

This 1958 ad appeared in *Smoke Signals*, the local newspaper.

In the days before air-conditioning was prevalent, a swim in the Gulf was the best way to cool off on a hot summer day. These ladies enjoying the surf are related to Carl Moseley, who owned the Big Indian Rocks Fishing Pier.

Of course children have always enjoyed sand and water. The beach was a great place for local families to spend an evening or a weekend. This photograph of Barry Broeske and his younger brother Buckie, whose parents owned the Sea Gem cottages in the 1950s, shows two smiling faces ready to play in the surf.

Dorothy Zubrod happily displays a porpoise that washed up on the beach at the Indian Rocks Inn. Note that when this photograph was taken in 1935, daily meals were served for 50¢.

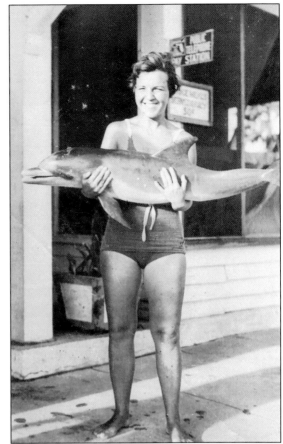

Members of the Moseley family pose for a photograph in July 1951 in front of their beach house on Twelfth Avenue. Back then, inner tubes provided a cheap and durable float for relaxing in the Gulf waters. This home was later moved to Fourth Avenue and became the Indian Rocks Historical Museum.

Swimming in the Gulf is an ageless activity. Young girls enjoy the water in 1955 in front of typical beach cottages tucked beneath the Australian pines that covered a large portion of the island. Today the Australian pines are gone, but the allure of swimming in the Gulf remains. Notice the narrow beach and the seawall along the shoreline.

Northerners flocked to Indian Rocks Beach during the winter months to enjoy the warm weather and sunshine that was typical even in December. A photograph like this one could be intended to make the folks back home just a little jealous.

Seven

COMMUNITY

The community's origin began with the establishment of two integral parts of any pioneer settlement—the post office and the church. Although homes and business were eventually scattered all along the barrier island, early community development began on the mainland. Land donated by Capt. John Lowe was used for a church and schoolhouse, both of which continue to serve the community. A cemetery adjacent to the church is still the burial place for area residents. The earliest recorded burial was that of Henry Whitehurst in 1880.

Volunteers are largely responsible for the growth and character of the Indian Rocks community. Groups such as the Lions Club, Veterans of Foreign Wars, Women's Club, American Legion, 4-H, and Civic Association provided gatherings for social as well purposeful activities. Fish fries, fiestas, auctions, fashion shows, dances, and dinners were held to raise money for civic improvements.

Of course the beach has always been the main attraction and has provided the backdrop for fishing, picnics, horseback riding, sailing, and sunbathing. The winter and summer brought an increase in population, with visitors coming either for warmth or to cool off, depending on where they came from and the season.

In 1925, the community of Indian Rocks, which included the island and part of the mainland, voted to form a civic government. Only 15 votes were cast, eight for incorporation and seven against. Commissioners sought financing for street improvements, streetlights, a sewer system, new bridge, and a variety of other projects. An unpopular request for tax dollars to fund these activities led to a decision two years later to abolish the incorporation.

Indian Rocks Beach did not permanently incorporate until 1955, when residents voted 208 to 93 in favor. The small island community at that time had about 2,500 residents and funding capability for streetlights, sewers, and parks. It continues to be an active, growing beach community whose population surges in the winter months as snowbirds fill seasonal condos, cottages, and other accommodations.

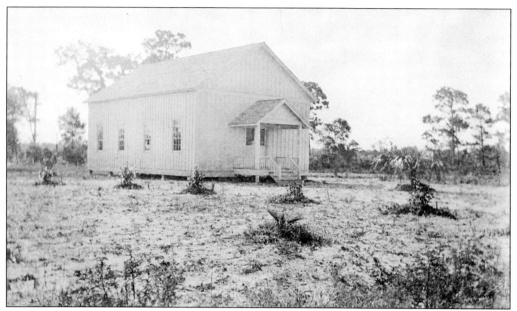

The first church in the area was organized on the mainland in 1872 under Rev. James Kilgore. A rough-board sanctuary was constructed in Anona and functioned not only as a community church serving all faiths, but as a schoolhouse as well. This newer building was erected in 1882 and is still part of the Anona United Methodist Church campus. The structure was not painted until 1888, when the old church was traded for $12 worth of paint.

With ingenuity, hard work, and a lot of faith, Fr. Roman S. Gromala and 12 members of St. Jerome's Catholic parish in 1959 converted a two-car garage into a little chapel that seated 60. The only money spent was for nails, paint, wiring, and carpentry for the altar rail. That modest chapel was used until it was replaced by a church built on 10 acres of land on the mainland.

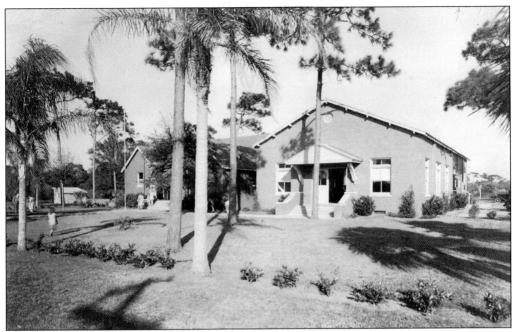

The first recorded history of Anona School dates to 1874, which makes it the oldest school in Pinellas County. Pictured here on the left is the brick building constructed in 1918 on Indian Rocks Road. It was a two-room schoolhouse with three grades taught in each room. That building, as well as the auditorium pictured on the right, is still in use today.

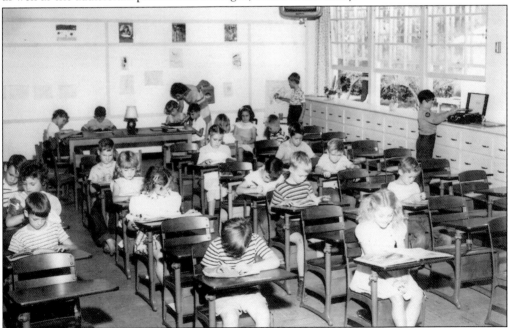

The burgeoning population of Indian Rocks Beach after World War II brought more students to Anona School. This classroom includes modern conveniences, such as a ceiling-mounted heater for use on cold winter days and a portable record player. Note the open window form of air-conditioning for the typically warm days.

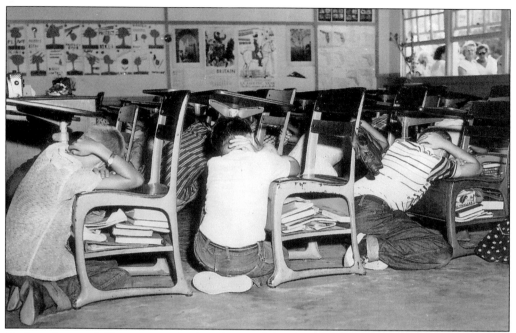

Duck-and-cover drills were practiced in Anona School as they were all over the nation in the 1950s. In anticipation of tornadoes or bombs, students were instructed to duck under their desks and cover their heads. Spectators are seen outside the window observing the procedure. In 1960, the PTA earned money from a variety show to purchase blackout curtains for the classrooms.

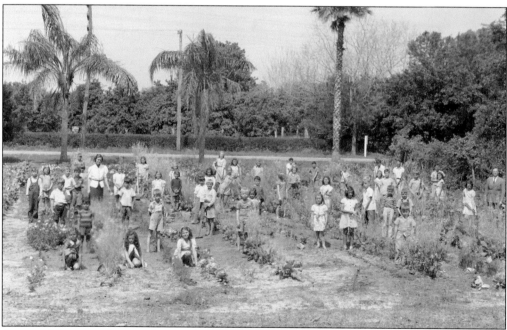

As part of the curriculum, students at Anona School learned agricultural skills by raising vegetables. Students and teachers are seen here in 1942 proudly standing in their gardens. Other school activities included an annual maypole dance and a school band, the West Coast Serenaders.

Sandra Rodriquez and Barry Broeske are pictured as king and queen with their court at Anona School's annual May Day event in 1948.

Poppy Day, held in May, recalls the end of World War I and was a time to honor those fallen in service. Activities included rallies, window displays, and poster contests. The donations collected by the American Legion helped veterans and their widows and orphans. Pictured are Nancy Norfleet, Gordon Geissler, Marty Prichard, and Sandra Freeman.

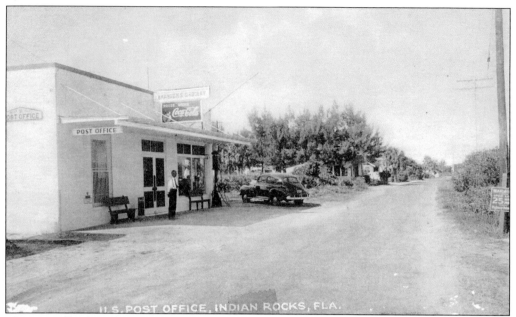

The post office has always been a hub of the community, from its initial days in Anona through the years when it was located near the bridge. In 1941, postmaster Camillus Brandon moved his general store and post office operation from the east end of the bridge to this building on the island just a few feet north of the bridge. The post office was the place to go and catch up on local news.

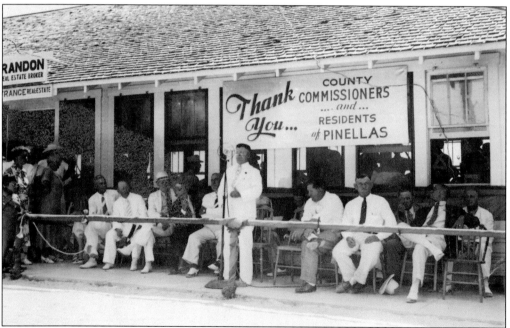

In the mid-1930s, the county contracted for the construction of a water system along the barrier islands. Water would be provided to 600 users from Pass-a-Grille to Indian Rocks. Standing in front of Brandon's Pavilion, A. G. McQuagge spoke to a civic group that wanted to express its thanks for the system. (Courtesy of Heritage Village Archives and Library.)

In 1948, an old military chapel was purchased and brought over by barge to serve as the clubhouse for American Legion Post No. 128. Funds to buy "the hut," as it was referred to, were raised through bingo games held at Brandon's Pavilion. In 1958, the hut at Gulf Boulevard and Fourteenth Avenue was sold, and the legion moved to 1515 Bay Palm Boulevard, which later became the Beach Art Center.

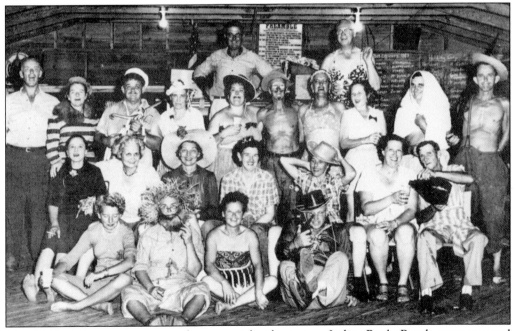

This 1950s Halloween party, one of many social gatherings on Indian Rocks Beach, was sponsored by the American Legion. The legion post was involved in a number of community service projects, including erection of a wartime aircraft warning service tower located on the east side of Brandon's Pavilion.

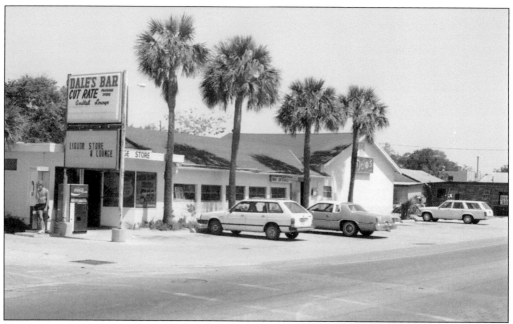

During World War II, Dale's Bar on Gulf Boulevard at Fourth Avenue was the nerve center of the community. At that time the coast guard maintained constant patrols, soldiers were stationed at sentry gates leading to the beach, and all homes were equipped with blackout curtains.

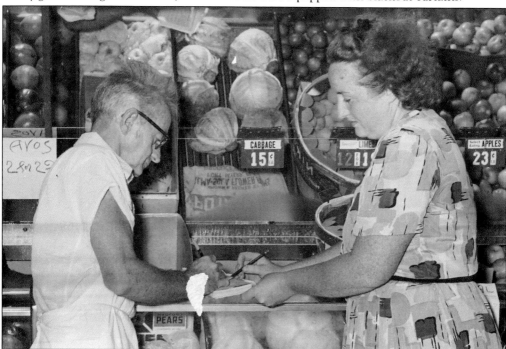

Historian, writer, and local resident Hazel Geissler covered news of Indian Rocks Beach for many years. She was a beach reporter who started her own newspaper, *Smoke Signals*, in 1955, which she published for five years. She is seen here in the 1950s at the local grocery store. Take notice of the produce prices.

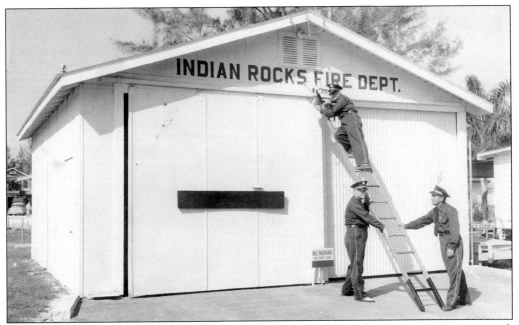

The Indian Rocks volunteer fire department was organized in 1951. After the city was incorporated, fire chief Wayne E. Luce was hired, a navy surplus truck was purchased, and two firemen were employed to man the station around the clock. This small wooden building on First Street, erected by volunteer firemen with scrap lumber and financial aid from residents, served as a garage for emergency vehicles.

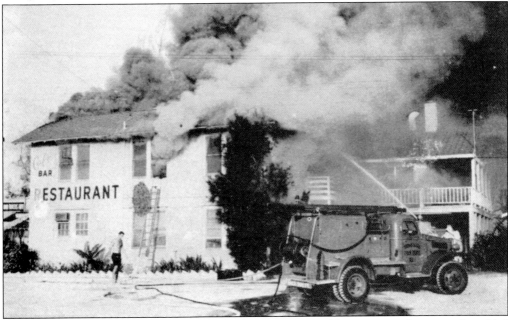

In the early 1950s, the Indian Rocks Inn, built in 1911, was sold to a group of women who added public dining rooms and ran it for a few years. The inn burned in 1963 following an extensive renovation. About that time, the fire district consisted of 1,850 homes and 106 commercial buildings plus 18 other structures.

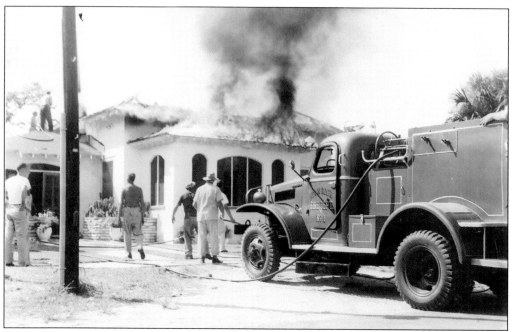

The Indian Rocks Fire Department is pictured on the job in 1951 as firefighters aboard Engine No. 1 bring a blaze under control. The fire was at the home of Bob and Frankie Klare at 1608 Gulf Boulevard. Fires and medical emergencies brought volunteer firemen rushing from all directions.

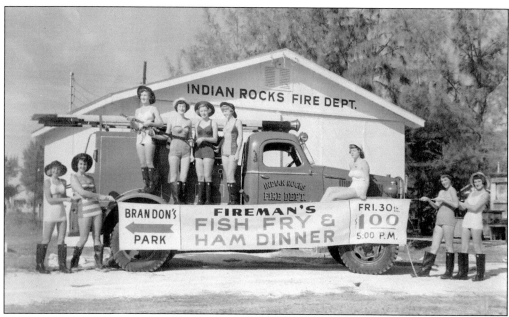

Funding the fire department was accomplished by donations and proceeds from dances and fish fries. To publicize such an event, these women posed in their fashionable 1950s beachwear and not-so-fashionable firemen's boots. Pictured from left to right are Pat Randall, Joan Zehnder, Deloris Beaty, Patty Wagner, Dorothy Zubrod, Jean Smith, Tania Olson, Marlene Matthews, and Joyce Meares.

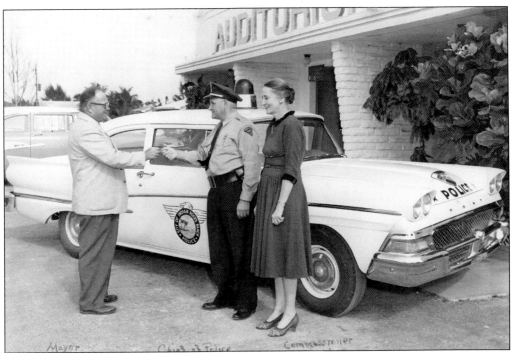

Soon after incorporation, the City of Indian Rocks Beach added a police department, cruiser, and two emergency phone lines. Chief Lawrence G. Regnier is pictured here in 1958 with William T. Jones, the first mayor, and city commissioner Sadie Manning.

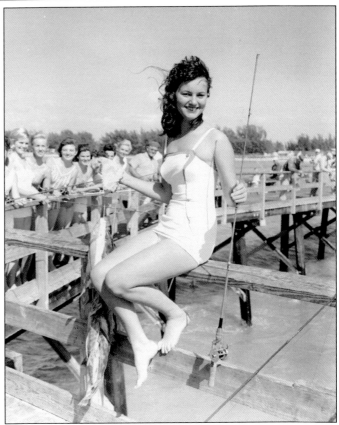

Bette Zubrod, granddaughter of one of the earliest residents on the island, was the 1961 Indian Princess when she was photographed on the Big Indian Rocks Fishing Pier. This picture was used on a chamber of commerce brochure to promote Indian Rocks Beach, the pier, and area attractions. (Courtesy of Florida State Archives.)

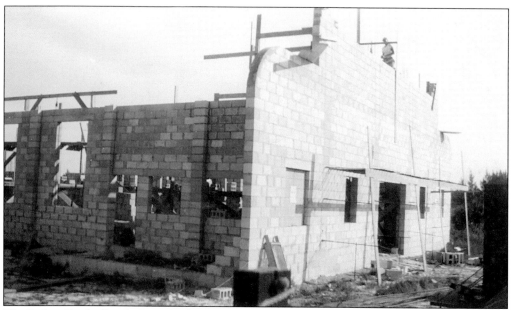

The Indian Rocks Beach Civic Auditorium was built over a period of several years using donated materials and volunteer labor. Funds were acquired through projects such as the ever-popular fish fries. The Civic Association sold the building to the city in 1958 to be used as the city hall. City offices were constructed on the south side and a library on the north.

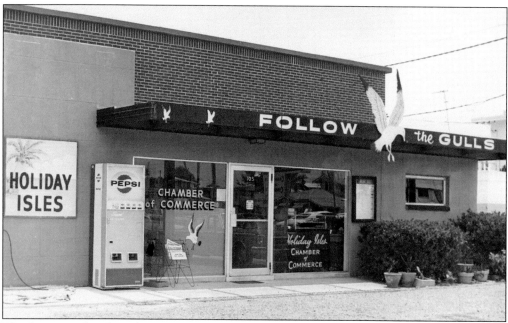

The first area chamber of commerce was started in 1925 by W. F. Finney. It was reestablished in 1956, and with the help of donations, auctions, and pledges, soon got its own home in this building located at the approach to the new Indian Rocks Bridge. In 1963 the chamber expanded and included other beach communities that together were called the Holiday Isles Chamber.

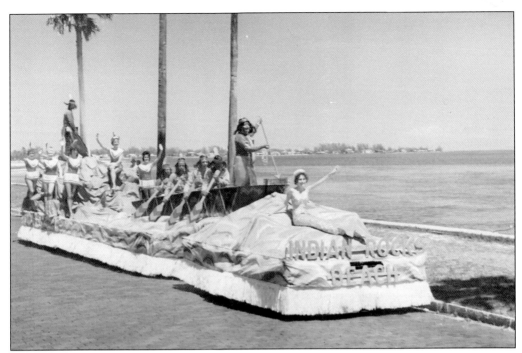

Since the early 1950s, Indian Rocks Beach has participated in parades both in the city and elsewhere. The Greater Indian Rocks Chamber of Commerce sponsored this float in the Tri-City (Clearwater, St. Petersburg, and Tampa) Suncoast Fiesta. It featured a costumed "Indian warrior" sending out smoke signals while surrounded by the Englandettes dressed as Indian maidens.

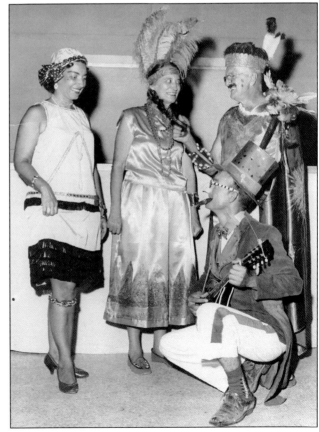

Indian Rocks Beach has a history of gatherings and celebrations that give the city a strong sense of community. In full costume and ready for a party are, from left to right, Berniece Gerber, Sadie and George Manning, and Mike Gerber (kneeling). The Mannings were civic leaders during the 1940s, along with the Gerbers, who owned the grocery store at Gulf Boulevard and Thirteenth Avenue.

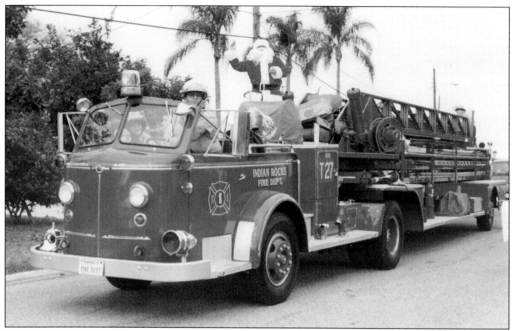

The tradition of a Christmas parade that winds through the streets of the city started many years ago. Santa Claus rode on the fire truck that followed behind decorated cars and floats. Local resident Bob Zubrod began portraying Santa in 1936 and continued entertaining children with his own brand of magic tricks for 44 years.

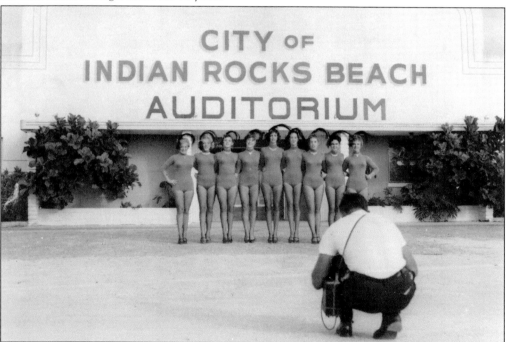

The Englandettes, from the England Studio of Dance, were being photographed in 1959 in front of city hall. The group often performed at local events such as Veterans Day rites and the policemen's ball. In the 1960s, they completed a tour through the southeastern United States.

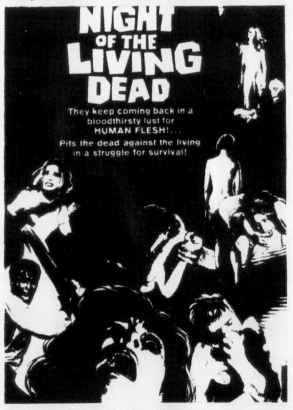

In the 1960s, the Indian Rocks Drive-in Theatre provided year-round evening entertainment for local residents and tourists. The drive-in was surrounded by orange groves, which dominated the landscape on the mainland across the bridge.

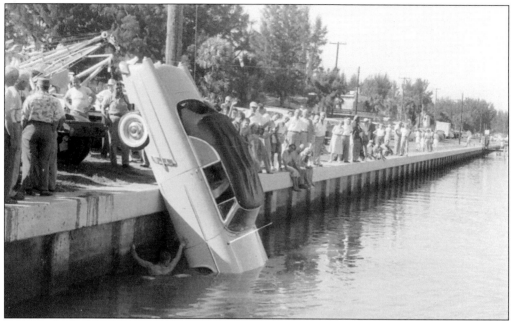

Mrs. Cain, who lived in the Narrows on Gulf Boulevard, reportedly was on her way to the Anona Church fish fry when she returned home to get something. What was intended to be a quick dash into her house turned into a major mishap when the empty car rolled from her driveway into the Intracoastal Waterway. This occurred in 1954 shortly after Gulf Boulevard had been relocated, which redirected driveways toward the Intracoastal Waterway.

Following several years of meeting in the American Legion hut, Calvary Episcopal Church made its first permanent home in this refurbished navy barge. The two-story structure served as a church, parish house, and rectory from 1956 until a new church was built in 1962. It continued in use as a fellowship hall until 1988.

This scene captures a ceremonial bricklaying at Church of the Isles when construction began on a sanctuary in 1955. Rev. Charles Wicks and his wife, Ida, are holding the block, while Laura Brown and Martin Forster look on. The site was donated by Laura and Robert Brown, local developers, who said, "If you will build the church, we will donate the land."

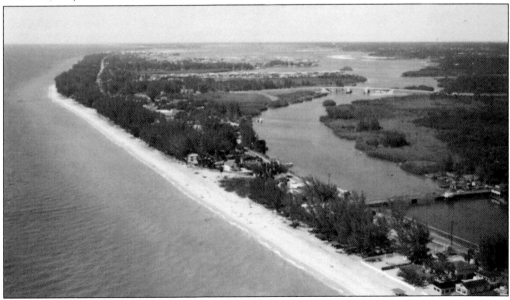

This 1959 aerial photograph was taken during the few months when both the old and new bridges still stood together. Once the new span to the north was opened for traffic, the old rickety bridge was destroyed. With easier access, both residents and visitors grew in number as the beach communities prospered. (Courtesy of Heritage Village Archives and Library.)

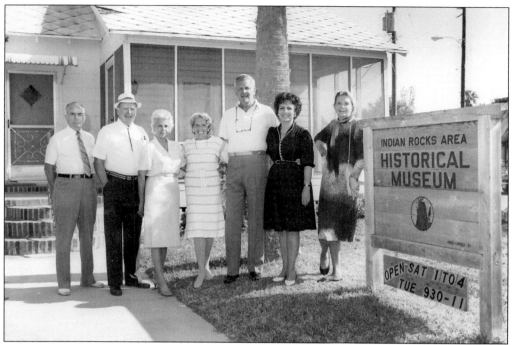

The Indian Rocks Historical Society and Museum was organized in 1981 by seven women dedicated to the preservation of local history. The museum is housed in a beach cottage that was built in 1939 on Twelfth Avenue and belonged to Carl and Caroline Moseley. Slated for demolition, the society had the house moved to Fifteenth Avenue. It was moved once more in 2003 to its current location on Fourth Avenue, making it more accessible to visitors.

This 1941 photograph shows Tampa lawyer Carl Moseley in an easy chair at his beach house. The customary tongue-and-groove interior walls were made of termite-resistant durable Miami cypress. Martha Moseley, Carl's daughter, remembers the cottage being crammed with sleeping accommodations for the many guests and family members who came for beach getaways.

Eight

HURRICANES

Indian Rocks Beach has been spared a direct hit by a hurricane, but some that came near took their toll. One of the worst tropical storms to hit the west coast of Florida came in 1848, when there was not much on the islands other than scrub plants to ravage.

Local residents recount a memorable storm in 1921 that came ashore at Ozona, about 20 miles north. That hurricane did considerable damage to Indian Rocks Beach. The pavilion seawall and dance floor were undermined and tilted at an angle. John Hendrick's fish camp at "Johnny's Rocks" was washed off its pilings and floated into the west end of the bridge, knocking it out of commission for a time. Bridge tender Harvey "Dad" Hendrick reactivated a rowboat ferry service until the bridge was repaired in 1922. Mrs. W. H. Dyrenforth, an island homeowner, had a horse and buggy stranded on the island after the storm, so she ran a horse-drawn taxi for arriving rowboat passengers.

Hurricane Donna in 1960 was a slow-moving storm with a lot of rain. In 1968, Hurricane Gladys caused more than $300,000 in damage to beachfront motels and seawalls with serious beach erosion. The following year the federal government granted funds to restore the beaches. Dredge and fill operations extended the beach an average of 60 feet.

Hurricane Elena in 1985 stopped just off the coast and threatened the area for three days. There were massive evacuations, flooding tides, heavy rains, and gales. The storm took away the big pier, Gulf-front homes, seawalls, beach sand, motel units, fish, and the tourist trade. Two months after Elena, slow-moving Tropical Storm Juan, although offshore, pounded seawalls and flooded streets once again. High tides and turbulent seas battered an already damaged community for two days.

Despite the one-two hurricane punch, the beach was not lost forever. A federal government re-nourishment program replaced lost sand, and the community united in the planting of sea oats to help retain it. The tourists eventually came back.

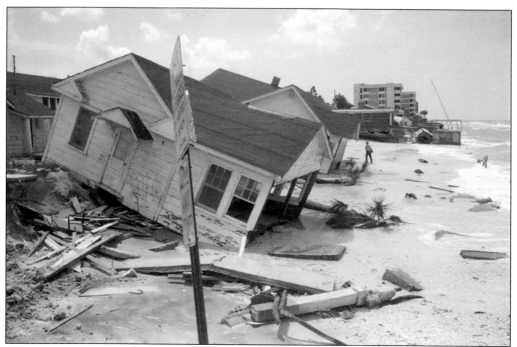

A house on Sixteenth Avenue lies in ruin, a victim of hurricane-spurred waves and unusually high tides. Elena, a Category 3 storm, swept away the sand that supported its foundation, taking patios and seawalls with it.

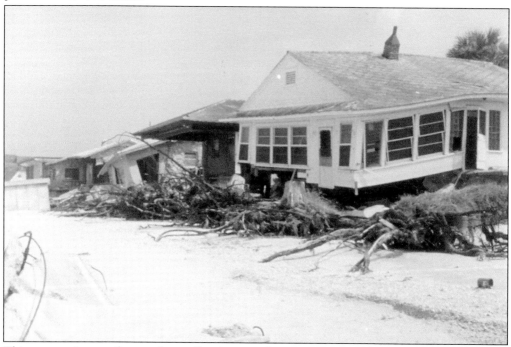

This cottage is one of many that suffered severe damage to its foundation. Many cottages and motels could not rebuild after the 1985 storm because of state restrictions on building too close to the high watermark.

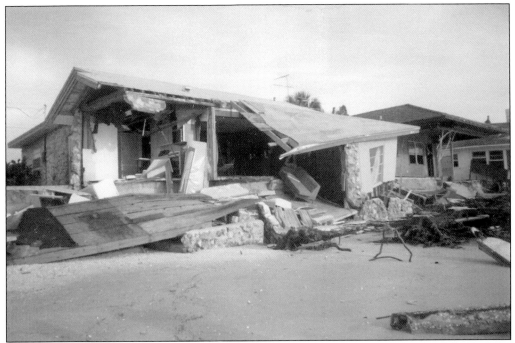

Just south of Fifteenth Avenue, Hurricane Elena destroyed the patio and the back half of this house, taking an enormous amount of the beach with it and killing any vegetation within reach of the tides.

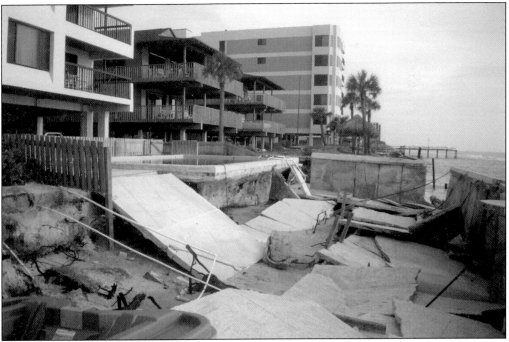

Following Elena, condos and motels found their pools undermined and seawalls lost to the Gulf. Structures such as Pelican Roost condos that had built farther from the water were spared major damage.

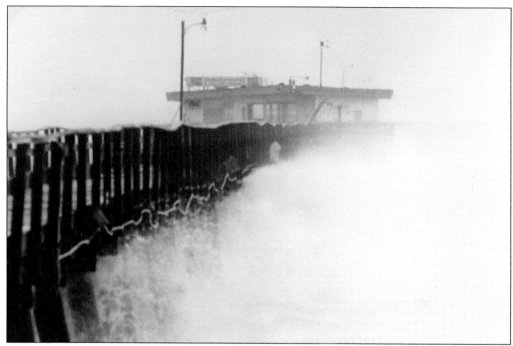
Pounding waves lashed against the Big Indian Rocks Fishing Pier for three days on Labor Day weekend of 1985 as Hurricane Elena stalled offshore in the Gulf.

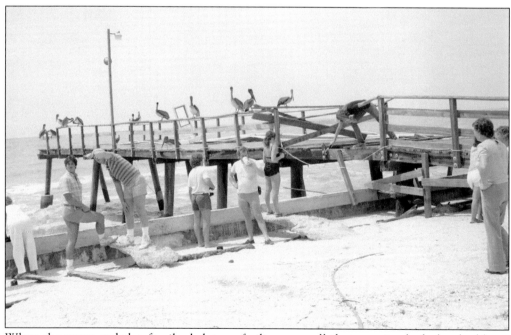
When the storm ended, a fragile skeleton of pilings was all that remained of what had been Florida's longest pier and a focal point of community life. Work crews removed much of what the storm did not take, leaving this remnant for exploration by curiosity seekers.

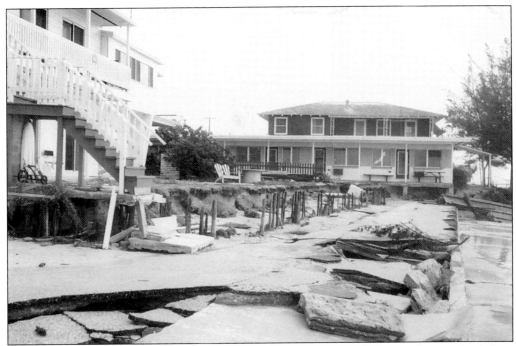

Hurricane Agnes was one of the largest June hurricanes on record. It gained strength on June 18, 1972 while moving toward the Florida panhandle and destroyed beachfront homes in Indian Rocks Beach as it went by. Locally, Hurricane Agnes caused $12 million worth of property damage and widespread beach erosion.

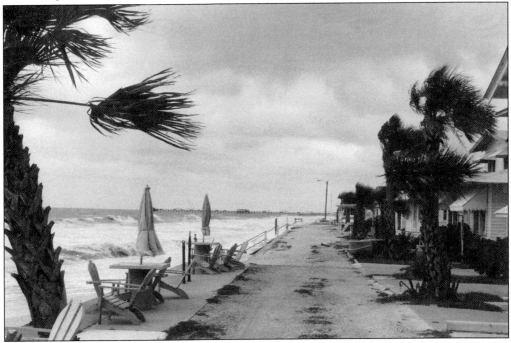

Hurricane Camille had minimal impact on Indian Rocks Beach as it passed through the Gulf in August 1969 before making landfall as a Category 5 storm in Mississippi.

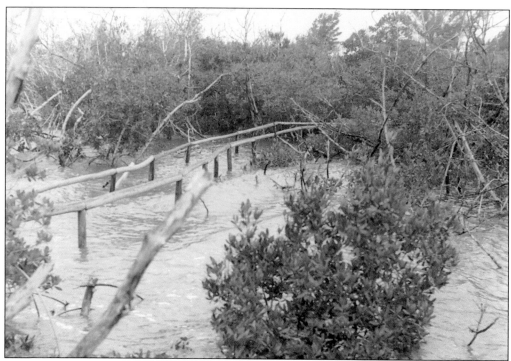
Paradise was under siege as Hurricane Elena's storm waters and high tides flooded beautiful Tiki Gardens in 1985.

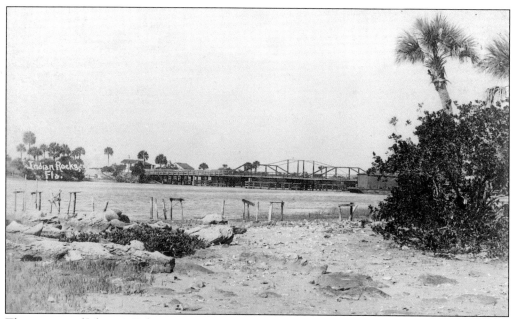
The remains of Johnny's Fish Camp after the 1921 hurricane can be seen in the foreground of this photograph, taken several years after the event. The building was dislodged from its moorings and swept into the bridge, which was heavily damaged. Today the scars of past hurricanes are barely noticeable in the quaint, historic community of Indian Rocks Beach.

About Indian Rocks Historical Museum

Painting by Mary Rose Holmes

Come visit our house. We are located in a historical beach cottage, nestled in beautiful Chic-a-Si Park (203 Fourth Avenue) at the heart of Indian Rocks Beach. Our museum is home to exhibits and displays that take our guests on a journey from prehistoric Indian times to the days of pioneer settlement up to the modern motel and condo eras.

Open Wednesday through Saturday
10:00 a.m. to 2:00 p.m.
Please call ahead, as hours are subject to change.
(727) 593-3861
Admission is free–donations are welcome.

Experience Indian Rocks as it was.

Discover Thousands of Local History Books Featuring Millions of Vintage Images

Arcadia Publishing, the leading local history publisher in the United States, is committed to making history accessible and meaningful through publishing books that celebrate and preserve the heritage of America's people and places.

Find more books like this at
www.arcadiapublishing.com

Search for your hometown history, your old stomping grounds, and even your favorite sports team.

Consistent with our mission to preserve history on a local level, this book was printed in South Carolina on American-made paper and manufactured entirely in the United States. Products carrying the accredited Forest Stewardship Council (FSC) label are printed on 100 percent FSC-certified paper.